IMAGES
of America

EARLY
ANAHEIM

Thirty-three-year-old deputy Los Angeles County surveyor George Hansen was hired by the San Francisco–based Los Angeles Vineyard Society on March 2, 1857, as its superintendent. His primary duty was the locating of appropriate land in the Southern California area on which to create the society's new model community. A civil engineer, Hansen arrived in Los Angeles in 1853 and had surveyed most of Los Angeles County by the time the contract for which he became known as the "Father of Anaheim" was begun.

ON THE COVER: In 1885, Center Street's substantial brick business buildings indicated the success of the original vineyard colonists. The town had become a profitable venture for the German pioneers that had stayed and invested in their community.

IMAGES
of America

EARLY
ANAHEIM

Stephen J. Faessel

ARCADIA
PUBLISHING

Published by Arcadia Publishing
Charleston, South Carolina

Printed in the United States of America

Library of Congress Catalog Card Number: 2005930111

For all general information contact Arcadia Publishing at:
Telephone 843-853-2070
Fax 843-853-0044
E-mail sales@arcadiapublishing.com
For customer service and orders:
Toll-Free 1-888-313-2665

Visit us on the Internet at www.arcadiapublishing.com

Dedicated to Susan,
who also understands the importance of those who have come before
and their contribution to the Anaheim community.

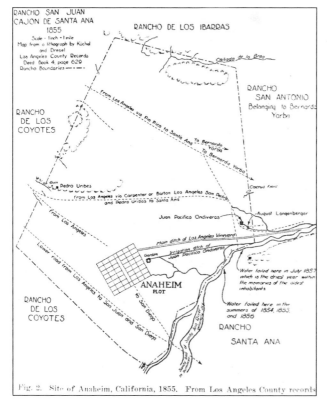

This 1855 map shows Anaheim's location in relation to Rancho San Juan Cajon de Santa Ana and surrounding ranchos, from Los Angeles County records.

CONTENTS

ACKNOWLEDGMENTS

My deepest appreciation goes to my patient and supportive wife, Susan, for all of the uncounted hours she has spent in helping me select the photographs and assisting with the captioning. Without her assistance and encouragement, this work would not have been completed.

I would like to thank Jane Newell, local history curator of the Elizabeth Schultz History Room, Anaheim Public Library for her generous help and support in the creation of this book. History Room staff members Ymelda Ventura and Sal Addotta have made my Monday research evenings productive. Special thanks go to Cheryl Van Trejen, who has kept me smiling during hours of microfilm research. Thank you Marcie, for lighting the way. Photograph credit goes to the Anaheim Public Library's Digital Anaheim project, which has made over 2,000 Anaheim images available to the residents, scholars, and history buffs throughout the world. In writing the captions, the work of the late Dr. Leo J. Friis, Anaheim's historian laureate, and John Westcott (*Anaheim: City of Dreams*) were relied upon. Don Dobmeier, my colleague from the Orange County Historical Commission, gave generously of his time as proofreader. My special friends Virginia Criss Geldman, Marion Wisser Harvey, and Margaret Hein Peter continue to live the history of their city. Through the efforts of the Anaheim Museum, Joyce Franklin, director; the Mother Colony Household, Harold Bastrup, president emeritus; and the Anaheim Historical Society, Cynthia Ward, president; the unique history of Anaheim will not be forgotten.

INTRODUCTION

Anaheim, literally *home on the Santa Ana River*, was Orange County's first modern community. In 1857, a group of 50 German immigrants incorporated themselves as the Los Angeles Vineyard Society and established a community based upon the propagation of the grape. Today, almost 150 years later, Anaheim, with a population of 360,000, is an international tourist destination and the center of a billion-dollar sports and entertainment complex.

Anaheim began with John Fröhling and Charles Kohler, both German immigrants who needed greater vineyard capacity for their expanding Los Angeles wine business. Fröhling contacted George Hansen, surveyor for the County of Los Angeles, and discussed with him a plan to create a colony of vineyardists in the Southern California area. A group of San Francisco investors organized themselves as the Los Angeles Vineyard Society and hired Hansen as their superintendent, with the task of finding land and water rights in the Los Angeles County area.

Hansen, who in 1855 had surveyed much of what is today's Orange County, was unable to consummate a deal with a number of landowners and, urged on by the impatient Vineyard Society members, contacted Juan Pacifico Ontiveros, whose land he had previously surveyed. Although he desired property near the dependable San Gabriel River, on September 12, 1857, Hansen negotiated a deal for 1,165 acres at $2 per acre of Juan Pacifico's Rancho San Juan Cajon de Santa Ana, which adjoined the Santa Ana River. An easement connecting the Santa Ana River to the new town site was also procured from neighboring landowner Bernardo Yorba. With the land purchased, Hansen could begin the layout of the town's 20-acre vineyard lots.

At a meeting of the Vineyard Society members on January 15, 1858, the name Anaheim was selected from the three suggested. Hansen was preparing the area for the arrival of the new colonists, using American Indian and Mexican laborers, who called the new settlement Campo Aleman or "German Country." By the fall of 1859, Hansen's Mission Grape vines were started, an irrigation system was installed, and a few rudimentary houses were built that would meet the first migration from San Francisco. By the autumn of 1864, Anaheim's 400,000 vines were already producing over 300,000 gallons of wine.

The original colonists were a varied lot, only one of which had any winemaking experience. Rather, these dreamers from San Francisco were a talented group of well-educated, refined gentlemen and ladies. Once relocated to this desert environment, the need to establish cultural arts opportunities gave rise to an opera house, social clubs, lodge halls, meeting rooms, and the requisite churches and schools.

Anaheim was taking on a look of permanence as some of the vineyards were subdivided into neighborhoods. A downtown with businesses of all types attracted citizens throughout the county. The region's first newspaper, the *Anaheim Gazette*, began publication in 1870 and recorded each advance the little community made. In 1875, a rail connection was made to Los Angeles, a depot located on land donated by an Anaheim pioneer. The thrifty Germans started a municipal water system in 1879, followed by an electrical system in 1895 that provided a source of income for the community. A police force and volunteer fire department protected the residents of this growing

little town, whose population had risen to 883 by 1880 and made Anaheim the second largest community in Los Angeles County. Residents saw the need for a separate regional government and campaigned for the establishment of the County of Anaheim. Eighteen years of political squabbles followed that finally resulted in the creation of Orange County, with Santa Ana as the county seat, in 1889.

In the mid-1880s began a devastating grape blight that killed nearly every vine in the region. The pioneers, now deprived of their livelihood, searched for other crops to replace their viticulture industry. Walnuts, chilies, and eventually citrus were found to be successful substitutes. German fortitude, faith, and even stubbornness carried them though times of adversity. The loss of their most important crop, cycles of flood and drought, pests, and distance from a major city all taxed the resolve of these pioneers. In spite of all of this, Anaheim became a successful venture.

By the early 20th century, the small, lightly built downtown businesses were replaced with substantial brick structures. The neighborhoods also expanded as the lure of affordable housing and Anaheim's "Mediterranean climate" encouraged the returning World War I vets to settle here, thereby doubling the city's population to over 10,000 by 1930. Anaheim was now being called the "Capital of the Valencia Orange Empire." Anaheim in 1921 began the California Valencia Orange Show, as much to showcase the area's most important product as to promote the community as a great location to live. The long-debated city park, with its lily ponds, Olympic-sized plunge, baseball diamond, and amphitheater would arrive after the frugal Germans finally arranged for the sales of $200,000 of bonds.

The roaring twenties also had a dark side for Anaheim when the Ku Klux Klan established itself in 1922. By 1924, activities of the Klan against the local Catholics and Latino residents, spearheaded by a rally in the city's new park that drew over 10,000 people, galvanized the community against the secret society. A bitter February 1925 recall election removed four Klan-affiliated city council members and, later, over half of the police force, who had been identified as Klansmen. The wounds to the community took decades to heal.

As the twenties gave way to the Depression years of the thirties, Anaheim's business climate cooled and several federal "make work" programs were used to keep the local residents employed. Long-needed infrastructure improvements, sidewalks, street trees, and La Palma Park (the town's second) all came about during this era. To add to the local economic woes, the earth rumbled on March 10, 1933, and what became known as the Long Beach earthquake took its toll on many of the town's business buildings and homes. Although Anaheim had no loss of life, its proud 1912 high school building was found to have significant damage and eventually would be rebuilt as a Works Progress Administration project. On the morning of March 3, 1938, after months of storms swelled the Santa Ana River, a low dike in the canyon area gave way and a flood crest washed over much of Orange County. The Latino communities of Atwood and La Jolla north of Anaheim were devastated, resulting in Orange County's largest loss of life. Anaheim's homes and businesses were hard hit, but the damage was eventually repaired. Many longtime residents still recall this catastrophe as the Flood of '38.

As the forties dawned on Anaheim, citrus was king. The community had survived both man-made and natural disasters. With a population now of over 11,000, the community waited for the next chapter of its growth to unfold. In less than two decades, the sleepy but proud little town, founded by 50 German vintners almost 100 years earlier, would become the center for entertainment and tourism in Southern California.

One

LOS ANGELES VINEYARD SOCIETY

THE PIONEERS

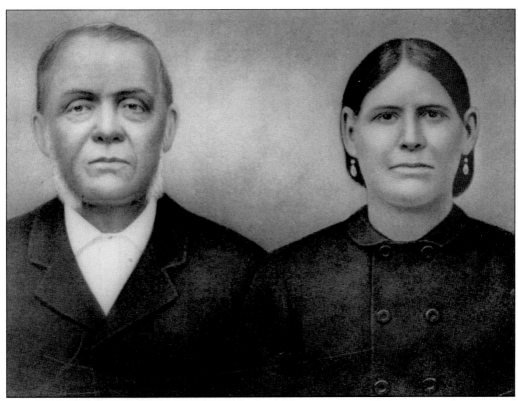

In 1857, Juan Pacifico Ontiveros and his wife, Maria Martina Osuna, sold the Los Angeles Vineyard Society's pioneers of Anaheim 1,165 acres of their 35,970-acre Rancho San Juan Cajon de Santa Ana for $2 per acre. Ontiveros later reported, "The land was poor, it would not support a single goat." Soon after the sale, Juan Pacifico and Maria moved to Santa Barbara County, where they had purchased a part of the Tepusquet Rancho.

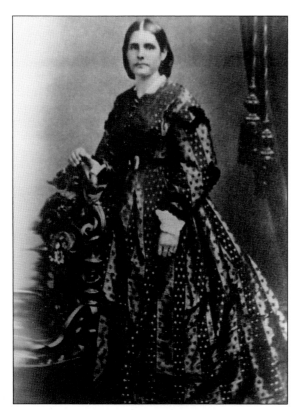

Petra Ontiveros Langenberger was the daughter of Juan Pacifico Ontiveros and Maria Martina Osuna and the first wife of August Langenberger, Anaheim's first merchant. August was born in Germany in 1824 and arrived in what later became Orange County in 1856 and established a home close to his father-in-law, Juan Pacifico Ontiveros. Petra died in Anaheim on September 7, 1867, and is the second recorded burial in the Anaheim Cemetery, the first being the infant son of August and Petra.

John Fröhling, a professional musician and native of Arnsberg, Prussia, arrived in California in 1853. In 1854, Fröhling and a fellow musician friend, Charles Kohler, started a modest wine business in San Francisco and followed that acquisition a year later with the purchase of a 20-acre vineyard in Los Angeles. Fröhling and Kohler's expanding wine business required a more substantial and reliable source of supplies that eventually resulted in the incorporation of the Los Angeles Vineyard Society and later create the town of Anaheim. (Photograph courtesy of James J. Friis.)

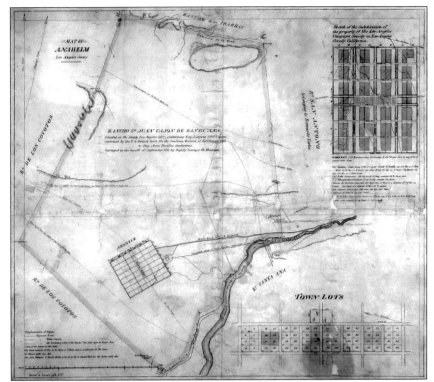

This hand-drawn map shows the Rancho San Juan Cajon de Santa Ana and its relationship to the Santa Ana River (to the southeast) and El Camino Real (The King's Highway), which connected the California missions. Surveyor George Hansen knew that the proximity to the Santa Ana River and the quality of the soil would assure the success of the Vineyard Society's new enterprise. Hansen used the local topography to his advantage, orienting the town so the main water canal could irrigate the future grapevines. This gave Anaheim its curious tilt to the southwest, in relation to the rest of the county.

This is a 1930 view of Anaheim's first permanent home, today called the Mother Colony House. George Hansen built it in 1857. It was dedicated as a museum on March 14, 1929, making it Orange County's oldest museum. The Daughters of the American Revolution donated the house to the City of Anaheim in 1954. Today, relocated from its original location on North Los Angeles Street (today's Anaheim Boulevard), it rests on a lot donated to the city by Marie Horstmann Dwyer, whose pioneer parents purchased the land in 1860.

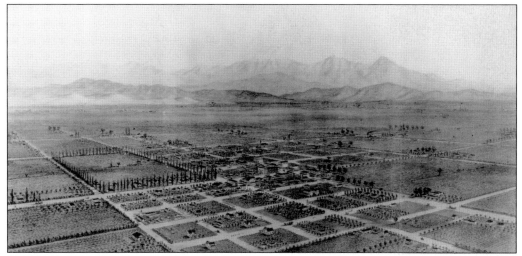

By 1880, Anaheim was the second largest community in Los Angeles County. This 1876 lithographed bird's-eye view of Anaheim shows a number of its vineyards, early public buildings, and churches, all in the shadow of the mountains.

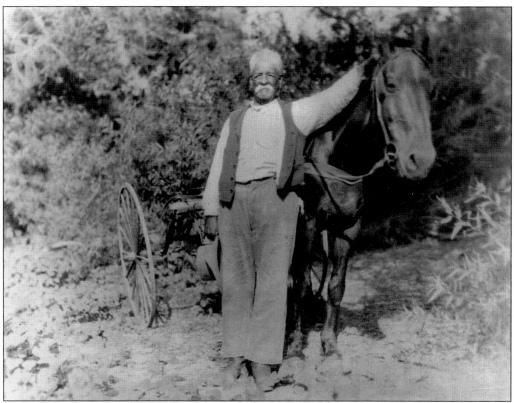

Maintaining the irrigation system that carried the waters from the Santa Ana River, five miles distant, was most important to early Anaheim colonists. The irregular flows of the river and the distance involved required a large amount of effort to get the water to the vineyards. This 1890s photograph shows Rafael Navarro and his horse Tom. For 60 years, Rafael worked as a *zanjero*, regulating the water in the *zanjas*, or ditches, for the Anaheim Union Water Company.

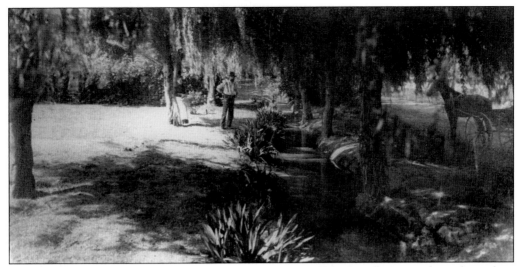

Anaheim, located on a dry alluvial plain, required a series of ditches, flumes, and canals totaling over 15 miles to carry the waters of the Santa Ana River to the newly planted mission grapevines. This 1880 view shows one of the main water ditches flanked by willow trees on Placentia Avenue (today's State College Avenue). Local rancher Richard H. Gilman and his wife, Helen, are pictured with their horse-drawn carriage enjoying this tranquil scene.

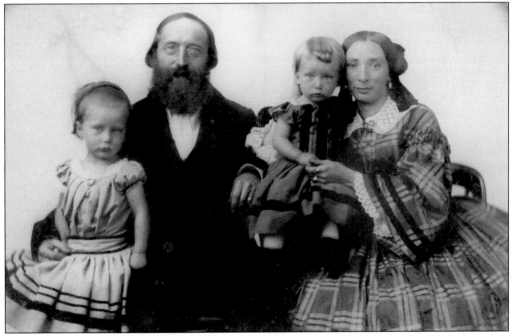

This formal photograph shows San Francisco resident John Fischer and his family before they left for their new home of Anaheim in November 1859. Fischer was the vice president of the Los Angeles Vineyard Society when it was formed in 1857 and was an original Anaheim colonist. His wife, Julia, seated with their daughter Amelia and son Frederic, was the sister of another Anaheim pioneer, John Hartung. John Fischer was very active in early Anaheim civic affairs, acting as Anaheim's first postmaster from 1861 through 1868. He was elected mayor in 1876 and ran Anaheim's Planter's Hotel from 1865 through 1882.

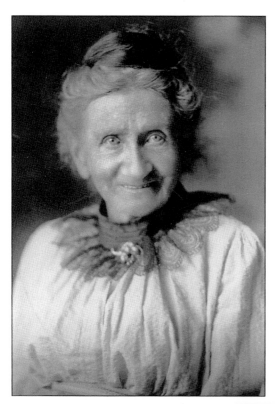

This formal 1920 portrait shows Amalie Hammes Fröhling, wife of John Fröhling, one of the original members of the Los Angeles Vineyard Society and the first vintner in Anaheim. Amalie and her betrothed, John Fröhling, arrived in Anaheim on September 12, 1859. Amalie was the first woman to be married in Anaheim on November 29, 1859. John Fröhling, while visiting his San Francisco offices in 1862, died of a very virulent form of tuberculosis at the age of 35. On August 10, 1865, Amalie married Charles F. Eymann in San Francisco but eventually returned to Anaheim, where she died on February 23, 1923. On the day of her burial, the flags of the community were lowered to half-staff to honor one of Anaheim's earliest pioneers.

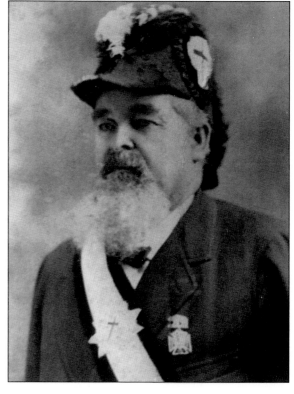

Theodore Reiser was an original Los Angeles Vineyard colonist who built the first winery and brandy distillery in Anaheim, located at Olive and Santa Ana Streets. Reiser was a prominent Anaheim civic leader and was elected mayor in 1877 and again in 1890. He was a member of Anaheim's Masonic Lodge and is dressed in his Knight Templar regalia in this photograph.

This 1871 portrait shows Theodore and Clementina Schmidt. Theodore, a native of Bielefeld, Germany immigrated to America in 1848 and became a member of the Los Angeles Vineyard Society in 1858. He is credited with suggesting the name Annaheim (later Anaheim) as the winning entry of the three voted on at the January 15, 1858, Vineyard Society meeting. His 40-acre Anaheim vineyard was noted for the tall poplar trees that he planted around the perimeter. He was Anaheim's first nurseryman and one of the first trustees of the Anaheim Cemetery Association. Clementina divorced Schmidt in 1874 and married August Langenberger, whose wife, Petra, had died in 1867. Clementine Street, located in what was the Langenberger tract, continues her memory today.

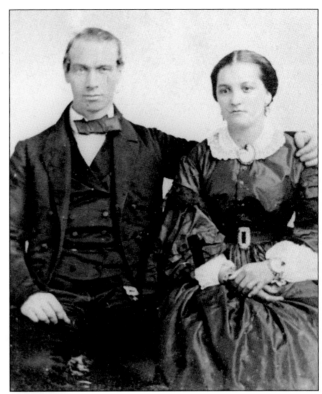

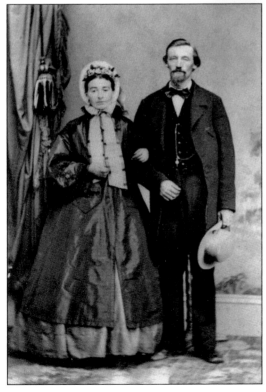

John Peter Zeyn was a young man of 27 when he joined the Los Angeles Vineyard Society in 1857. John and his wife, Sophia Menke Zeyn, moved to Anaheim in 1859 with the first migration of San Franciscan owners. He ran a general merchandise store under the name of Zeyn and Company. Zeyn was active in the civic affairs of the small town and became a trustee of the school board and the Anaheim Cemetery Association as well as mayor of Anaheim in 1883. Today Zeyn Street recognizes his early contributions to the community.

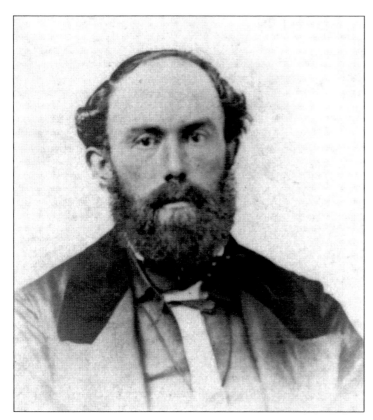

Charles "Carl" S. Rust was a native of Brunswick Germany who arrived in California in the 1850s. He moved to Anaheim in 1861 and acquired two vineyard lots in the northwest section of town, both of which he placed in the name of his wife, Sophie. On May 11, 1868, he died in a freak accident while driving a team of horses to Los Angeles.

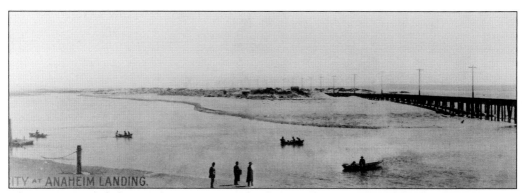

ITY AT ANAHEIM LANDING.

The vintners needed a simpler way to transfer their products to steamships, because the mule trip to the Port of Wilmington was costly. The colonists investigated a number of sites along the coast and selected a location at Alamitos Bay to set up the Anaheim Lighter Company, which would transfer cargo to the ships via small cable-pulled barges. After the flood of 1867, the lighter company relocated farther south at a new port called Bolsa Chiquita. The location became known as Anaheim Landing, pictured here in 1899. Now known as Anaheim Bay, it was used as a vacation spot for many years, and today rests inside the U.S. Naval Weapons Station.

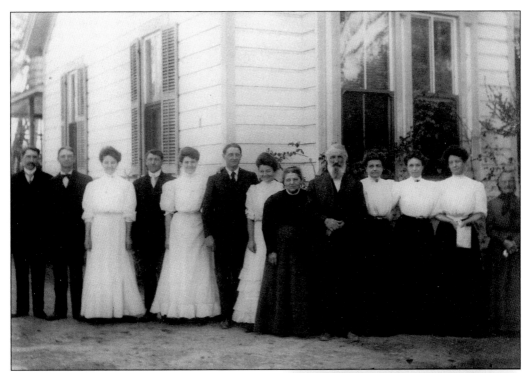

Timm John Fredrick Boege left his native
Holstein, Germany and arrived in Anaheim in
1861. He became engaged in the blacksmith and
freighting business and started his vineyard in
1874. This c. 1908 photograph shows his family
of 10 children in front of their home on West
Center Street (now Lincoln Avenue). Timm,
a strong Anaheim booster, was the founder of
the local German-American Bank and donated
40-acres of land for the site of the Southern
Pacific Railroad station in 1875. The oldest
son, Charles, (far left in this photograph) was
the longest-serving elected official in Anaheim
history, from his first election as city treasurer in
1908 until his resignation in 1939.

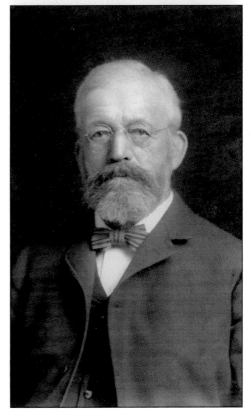

This 1900 portrait shows Frederick A. Korn,
who purchased vineyard lot F7 and started a
winery in Anaheim in 1869. When he married
the widow Sophia Horstmann (also in 1869),
he added vineyard lot C7 to his holdings.
Korn was very active in early Anaheim civic
affairs, serving as a director of the Anaheim
Union Water Company (the successor to the
Los Angeles Vineyard Society) and a number
of terms as an Anaheim city trustee (now city
council member).

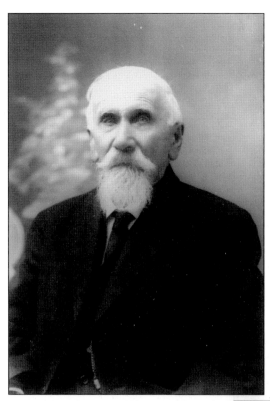

Theodore Rimpau, born in Hamburg, Germany, sailed for California in 1848. In 1872, the Rimpau family arrived from San Francisco as one of Anaheim's early German vintners. His residence, located at the corner of Broadway and South Palm Streets (now Harbor Boulevard) was a stately two-story home with a covered porch, formal garden, trees, and an orange grove. After Gov. Newton Booth moved to disincorporate the bankrupt City of Anaheim in 1872, Theodore Rimpau, August Langenberger, and Theodore Reiser were appointed as the board of commissioners to settle the economic affairs of the city by selling city property for $338.21 to clear the community's debts.

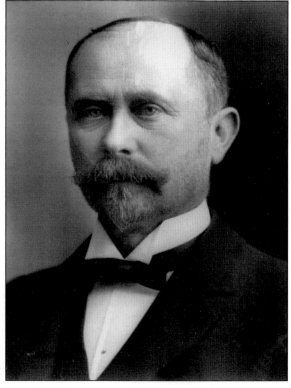

Fredrick A. Hartmann was the son of Jacob Hartmann, one of Anaheim's original pioneers. The elder Hartmann supervised the planting of a cactus fence around the original boundaries of Anaheim in early 1863, to protect the vineyards from the local roaming wild cattle that found the irrigated grapevines especially refreshing. Fredrick was a community leader in his own right, donating the Pioneer Gate at the Anaheim Cemetery in 1915 and erecting a large business building replacing the old Reiser Opera House in 1917.

This is a 1915 portrait of Adelheid Koenig Schulte, widow of pioneer Anaheim vintner William Koenig. William, who first worked for John Fröhling, later owned the largest winery in Anaheim. Adelheid presented to the community the first El Camino Real bell, which was dedicated in Anaheim on February 5, 1911. The iron bells, hung on poles, marked the original path of the padres as they developed the California missions, beginning in 1769.

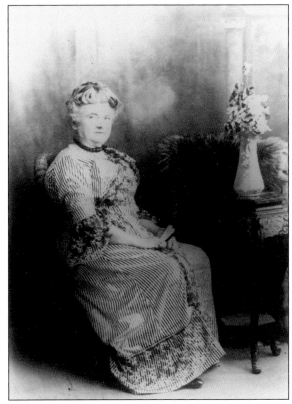

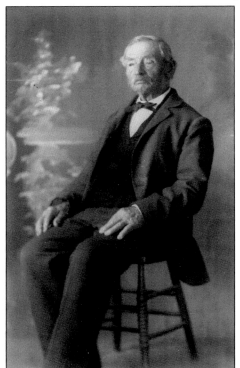

Carl August Lorenz, a native of Prussia, is pictured in 1900. He owned a vineyard at the southwest corner of Lemon and Santa Ana Streets. His daughters Elmina and Louise were two of the nine children that attended Anaheim's first school, located in an old adobe Indian lodging house. Carl had the distinction, as Anaheim's oldest living pioneer, to "push the button" the night of April 11, 1895, inaugurating Anaheim's new electric power system.

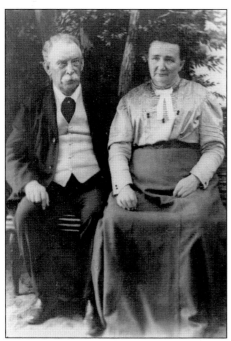

Henry Kroeger, born in Holstein Germany in 1830, arrived in San Francisco in 1854 and opened a cooperage shop. He married Sophia Husmann from Hampstadt, Germany, when she joined him in 1857. Kroeger was a well-respected businessman in Anaheim, building the Commercial Hotel in 1872 and Kroeger Hall in 1874. He was elected the second mayor of Anaheim and held that position from 1871 through 1872.

This late-1880s, hand-drawn plat map of Anaheim indicates the original layout of the community and the names of the first vineyard owners. Also noted are the types of grapes that were planted on each 20-acre vineyard lot and the years the grapes started to die out from a mysterious disease later called the "Anaheim Disease." In 1892, Dr. Newton B. Pierce identified the cause of this massive blight to be a microscopic leafhopper. Vineyard owners today are still fearful of what is now known as "Pierce's Disease."

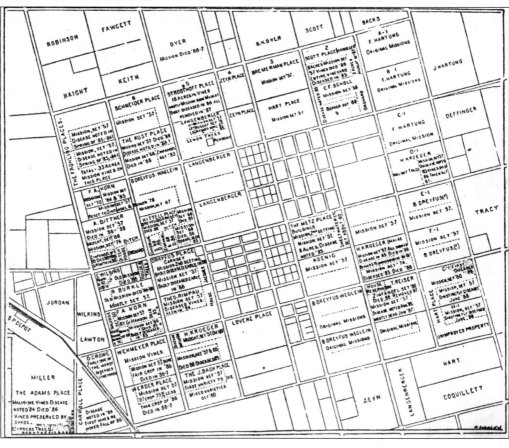

Two

The Mother Colony
The Birth of a City

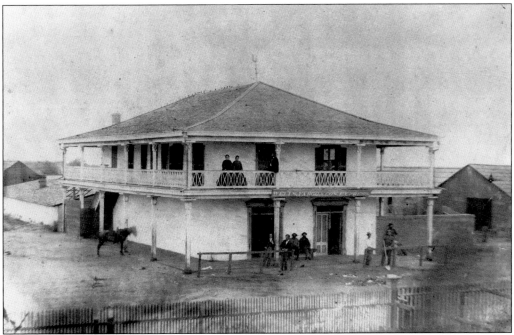

In 1857, two of Anaheim's pioneers, August Langenberger and Benjamin Dreyfus, formed a partnership to run the town's first general merchandise store. After occupying a temporary building at 128 West Center Street (today's Lincoln Avenue), they built this two-story adobe building at 114 West Center Street. In addition to the Langenberger living quarters on the second floor, an additional large room was frequently used for dances and other social functions. This rugged building survived the historic flood of 1862 that heavily damaged many of the lightly built structures in the town. In 1873, Langenberger located to a new store building at the corner of Lemon Street and Center. This old adobe, one of Anaheim's earliest buildings, was razed in 1915, when owner John Cassou developed a new business block of modern buildings.

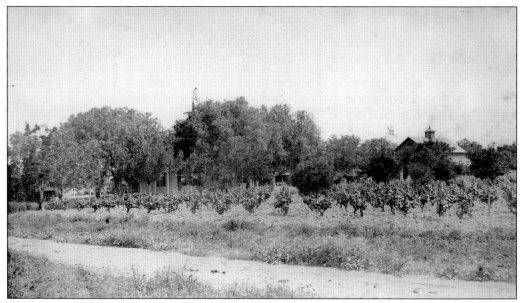

Theodore Reiser's residence and vineyard is pictured in the mid-1860s. Located at the corner of Melrose and Santa Ana Streets, the vineyard helped to supply Reiser's nearby winery. Reiser, who distilled the first Anaheim brandy, also erected a 75-foot by 100-foot, two-story brick building downtown in 1888. The upper floor, designed as a large auditorium, became known as Reiser's Opera House.

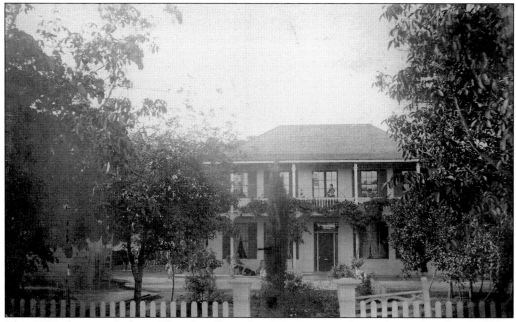

This 1880 photograph shows Theodore Reiser's stately two-story home, located at the southeast corner of Santa Ana and Olive Streets. Reiser was an original member of the Los Angeles Vineyard Society and his winery was Anaheim's first.

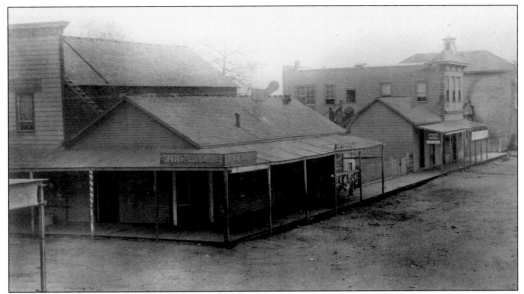

In 1870, Anaheim's Wine Room saloon was located at the crossroads of Anaheim's main streets, Center (now Lincoln Avenue) and Los Angeles (now Anaheim Boulevard). Loring W. Kirby served the refreshment needs of the local and traveling public from his business. His was one of many bars and saloons dotting Anaheim's downtown streets at this time.

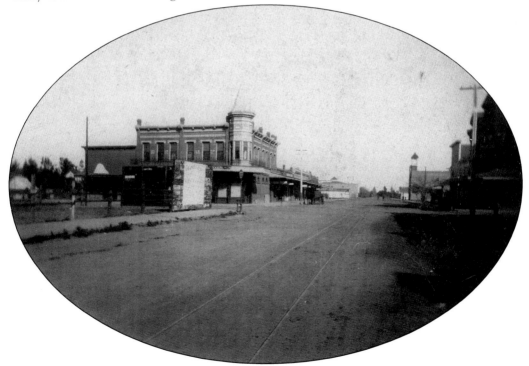

This early 1890s view of Anaheim's Center Street (now Lincoln Avenue) is looking east. The bare corner shows where the twice-built Planters Hotel burned down in 1890. The imposing brick Federman building is on the left, and the tower of Anaheim's city hall is in the distant background at right.

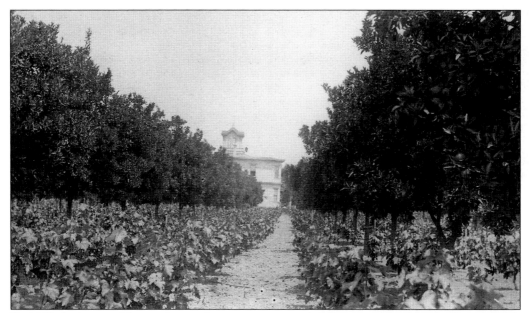

By 1887, the home of August Langenberger was surrounded by vineyards and orange trees. With his partner Benjamin Dreyfus, Langenberger operated one of the first general stores in Anaheim. He was the son-in-law of Juan Pacifico Ontiveros, from whom the 1,165 acres for Anaheim was purchased. His residence, which he called Villa Mon Plaisir ("Home of My Pleasure") was situated on Sycamore Street. One of his original 20-acre vineyard lots was sold to the City of Anaheim in 1920 for the development of the city park (now Pearson Park).

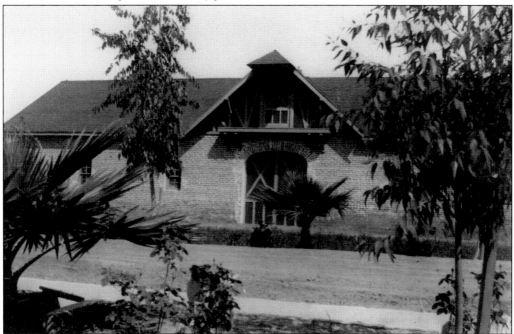

This c. 1897 view is of August and Clementina Langenberger's distillery and winery, located on Sycamore Street. Langenberger, Anaheim's first merchant, had an extensive vineyard surrounding his stately home.

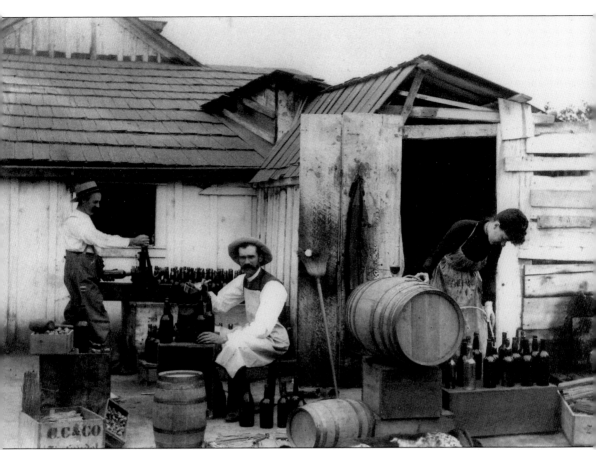

Dr. James Hovey Bullard, in addition to being one of Anaheim's earliest physicians, ran a modest winery. As this 1885 photograph demonstrates, winemaking at this time was often a small affair, with the vintner doing a great deal of "hands-on" activity. Dr. Bullard was an Anaheim civic booster who purchased a stock interest in the Anaheim Improvement Company, which had plans to build the long-awaited Hotel Del Campo. The hotel, a magnificent structure for its day, never lived up to the financial expectations of its promoters, and after a number of owners it was razed in 1905.

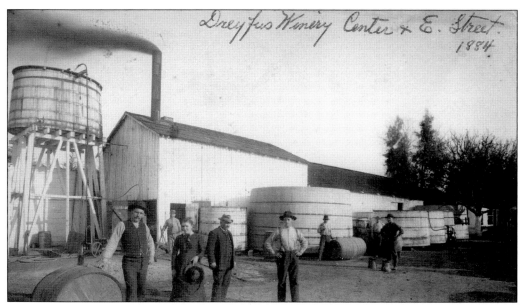

This 1884 view shows Bavarian-born Benjamin Dreyfus's first winery on East Center Street (today's Lincoln Avenue). Dreyfus (standing third from the right of the wine barrel) was one of Anaheim's pioneers and formed a partnership in 1857 with August Langenberger, to run a mercantile store in the new town. Later, Dreyfus organized the United Anaheim Wine Growers Association, a marketing firm made up of Anaheim vintners. His own firm, B. Dreyfus and Company, became the largest wine distributor in California by the late 1870s.

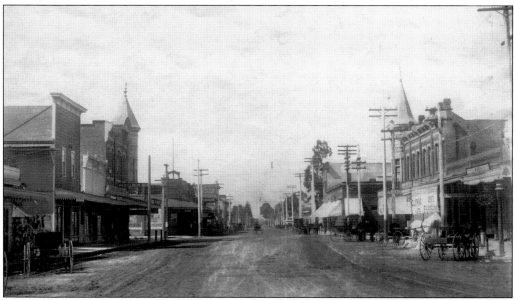

This 1901 view of Anaheim's Center Street (now Lincoln Avenue) is looking west. Pictured, from left to right, are (left side of the street) the Palace Restaurant, Bruce's Candy Kitchen (which also housed the public library), and the Metz block of business buildings; (right side of the street) Bentz B. Steadman Meats, S. S. Federman clothing, telegraph office, post office, and Pellegrin's Music Store. Street paving would take another decade, and ornamental streetlights appeared 14 years later.

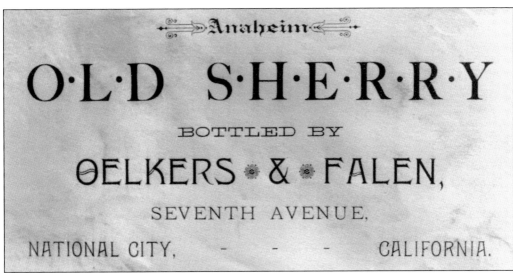

O·L·D S·H·E·R·R·Y

BOTTLED BY

OELKERS & FALEN,

SEVENTH AVENUE,

NATIONAL CITY, - - - CALIFORNIA.

Henry Oelkers was born near Hamburg, Germany, in 1856 and came to Anaheim in 1884 to assist his uncle William Koenig in his winery. Oelkers was the superintendent and manager of Koenig's winery and vineyards. This label of "Anaheim Old Sherry" notes Oelkers's brief partnership with a Mr. Falen. Henry and his wife, Lizette, adopted a young son George, who was later employed by the City of Anaheim Municipal Water and Light Department, for 41 years retiring in 1964 as its superintendent.

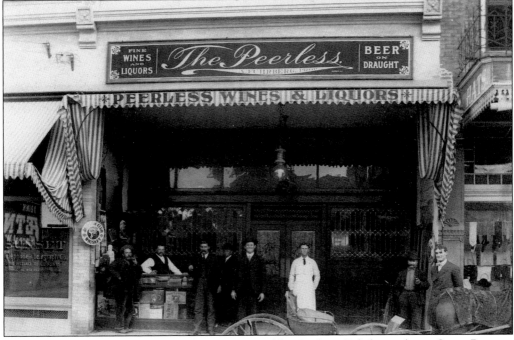

This 1903 view of Anaheim's Peerless Bar, owned by Andrew Fuhrberg, shows Oscar Renner, one of the principals of Anaheim's SQR mercantile store, pictured at far right. Located at 106 North Los Angeles Street (today's Anaheim Boulevard), the store was one of many drinking establishments in the community. At one time, Anaheim boasted more saloons than churches, something residents of neighboring dry towns appreciated.

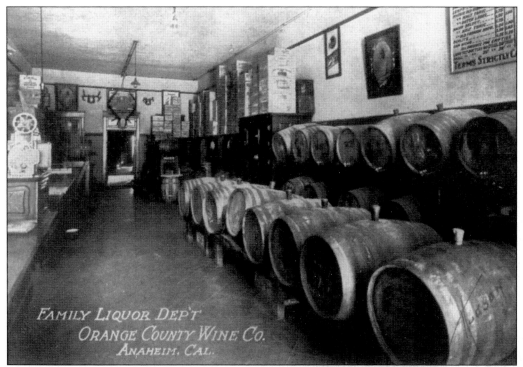

This 1915 interior view of the Family Liquor Department of the Orange County Wine Company, located at 133 West Center Street (now Lincoln Avenue), shows a large stock of wine barrels. By this time, almost no Anaheim wineries were left operating, but Anaheim wine and liquor merchants were still prepared to meet the demand for spirits of all kinds.

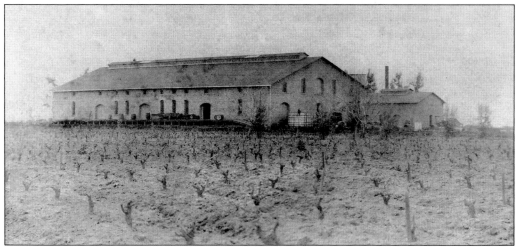

In 1885, Benjamin Dreyfus's success as an Anaheim vintner encouraged him to build this large 80-foot by 200-foot brick winery southwest of Anaheim. By far the most ambitious building project of its day in town, its construction coincided with the outbreak of "Anaheim Disease," which was later renamed Pierce's Disease in recognition of the USDA agent who studied the problem in 1892. Dreyfus, who died in early 1886, did not live to see the demise of the industry he pioneered in Anaheim or the structure he had recently built. This building, which remained an Anaheim landmark for decades, was used for a variety of purposes over the years, until razed in 1973.

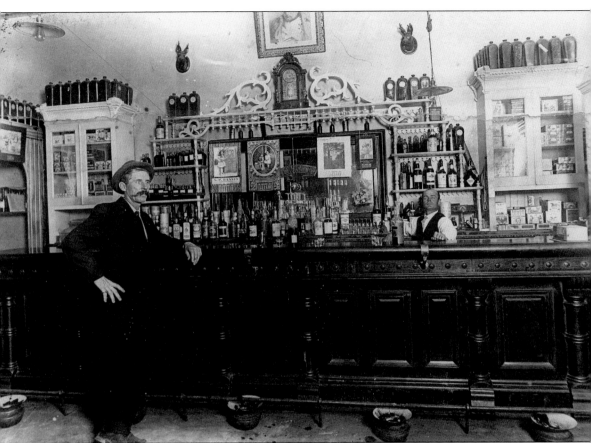

This turn-of-the-century view shows the interior of Napoleon Hart's Place, one of Anaheim's many saloons. It was located at 117 East Center Street (today's Lincoln Avenue). Pictured are Dee Jackson, manning the ornate bar; and Anaheim local Duke Paschall, standing on the left. Hart's Place maintained a fine stock of wines, spirits, and cigars, with the requisite spittoons along the foot rail.

This 1931 photograph shows the long-vacant California Brewery that was located at 113 West Adele Street. Friedrich Conrad built it in 1878 and the Anaheim Brewery in 1888. Unfortunately for the pioneer vintners, the grape blight of the late 1880s killed nearly every grape vine in the area. This, combined with the passage of the 18th Amendment in 1920, prohibiting the sale and transportation of alcoholic beverages, virtually brought to an end Anaheim's dominance in the wine and beer industry. By this time, citrus had become Anaheim's major industry and most of the pioneer wineries and breweries had been converted to other uses or torn down.

Three

NEIGHBORHOODS
AND FAMILIES

After Anaheim qualified for cityhood in 1870, one of the first things done was to establish ordinances concerning fire protection. A lightly trained volunteer organization was soon formed, while the *Anaheim Gazette* reported that more damage occurred due to the firemen's efforts rather than the effect of the flames themselves. Reorganization in 1871 resulted in the Anaheim Fire Company No. 1, which received $62 worth of hooks and ladders from the frugal city trustees. Another reorganization in 1883 created Confidence Fire Company No. 1, with Fred C. Rimpau as its chief.

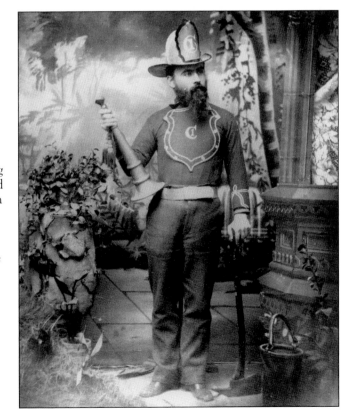

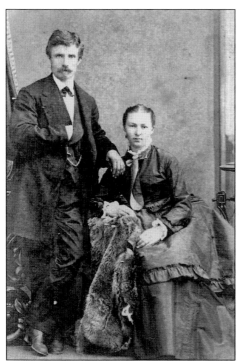

Brothers Ferdinand and Joseph Backs operated an upholstery, furniture, and undertaking business. In the fall of 1871, they were awarded the contract to make the mattresses for the newly built Anaheim Hotel that was "dedicated to the cause of hospitality." This wedding portrait of Ferdinand Backs and Louise Werder Backs was taken on January 25, 1875.

The Werders were one of the original 50 Anaheim colonist families to settle in Anaheim in 1859. Herman Werder was one of the three school board members in the 1860s. In this 1885 photograph, Johanna Brett Werder and Herman Werder stand under a tree in the front yard of their two-story, white clapboard home located at the corner of Citron and South Streets.

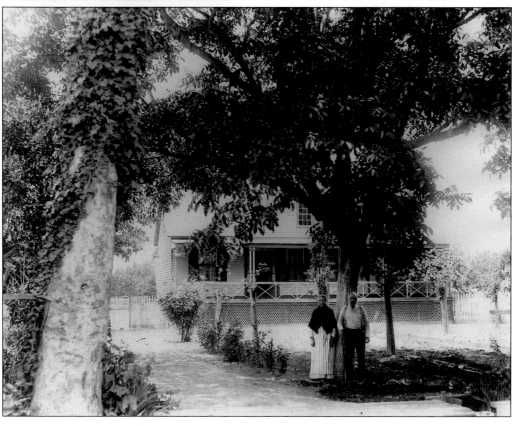

This 1896 portrait of Madame Helena Modjeska shows the famous Polish actress and early Anaheim resident dressed in her Victorian finery. She and her husband, Count Karol Bozenta Chlapowski, immigrated to the United States in 1876. Hearing that Anaheim was founded by a group of transplanted Europeans, she located into what was a dusty, yet promising, community. The hardships of the new land, however, forced her back onto the American stage. After touring the country in a variety of Shakespearean roles, she and her husband relocated to a Santiago Canyon ranch that she named "Arden" after the fictional forest in Shakespeare's *As You Like It*. Her first name has been applied to an Anaheim street and her last to a canyon and peak in the Santa Ana Mountains.

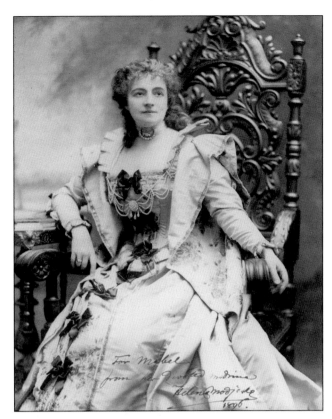

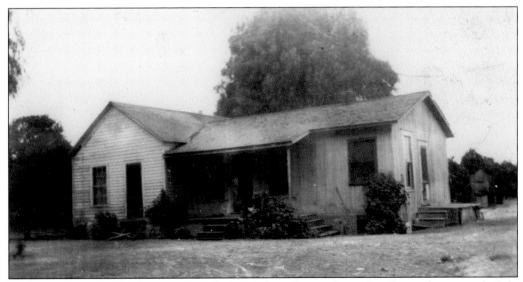

Madame Helena Modjeska's Anaheim home and ranch were located well out of town, and while she had dreams of living in a perfect utopian society, the harshness of the dry Southern California desert soon overtook them. After only a few months, the colony of Polish artists broke up, after Modjeska had spent over $15,000 attempting to make their new venture successful. This 1876 photograph shows the Anaheim Modjeska house located at East Center Street and today's State College Avenue.

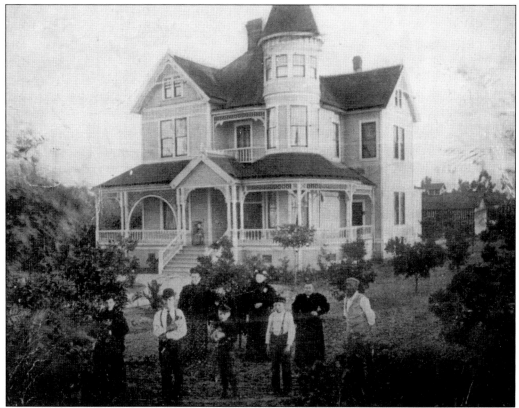

John Gottlieb Woelke, a Chicago restaurateur, came to Anaheim in 1894. He traded the Argyle Hotel in Los Angeles for this Queen Anne Victorian–style, three-story home. It was originally located at 520 West Center Street (now West Lincoln) and Palm Street (now Harbor Boulevard). The house was moved in 1949 to 418 North West Street. Later owner John Dwyer deeded the home to the Red Cross in 1953. Here members of the Woelke family pose in the front yard.

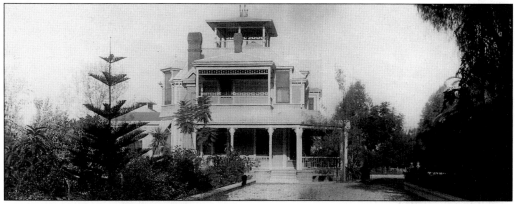

This 1895 home was the first residence of Peter and Josephine Weisel and their nine children. Located on Walnut Street, north of Ball Road, it was designed by architect Hans Larson, who later married Weisel's daughter Della. "General" Julian O. Royer purchased the home in 1905, and it was resold to the Lutheran Home in 1936 and later razed in 1954. Peter Weisel arrived in America from Germany and settled in Anaheim in July 1893, purchasing 20 acres at the northwest corner of Ball Road and Walnut Street.

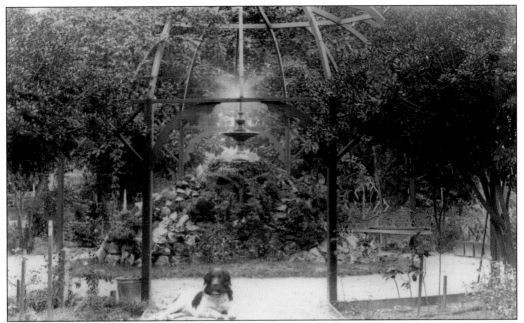

This lush rock garden and fountain were on the property of Clementine and August Langenberger located on Sycamore Street. Langenberger owned a magnificent home in the north part of early Anaheim that was surrounded by his vineyard and early citrus groves. Although the home and property became victim of neighborhood development in the early 1920s, this garden survived to be in the backyard of the home at 510 North Clementine Street.

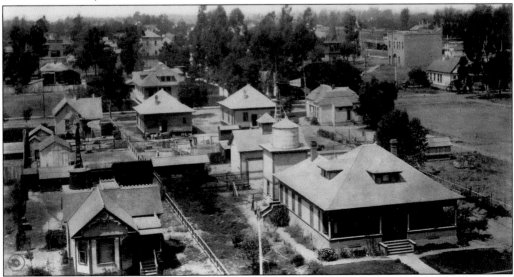

This elevated view of turn-of-the-century Anaheim was taken from the tower of the Del Campo Hotel at the corner of Center Street (now Lincoln Avenue) and Olive Streets. Looking south, the photograph shows the modest residence of C. E. Ramella on the lower left and the residence of George E. Boyd, co-owner of the Orange County Preserving Company, on the lower right. The rural atmosphere of the town is still evident, with houses still having the usual necessary outbuildings as well as the windmills that supplied the two-story tank houses that stored domestic water.

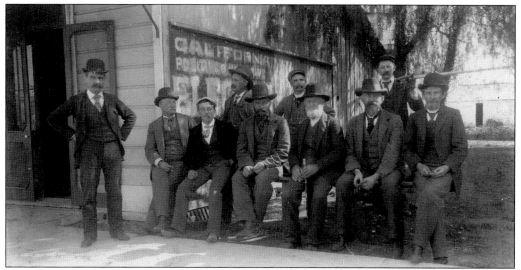

In this c. 1889 photograph, 10 businessmen of the Anaheim Ways and Means Committee are sitting outside the Metz Block Building at 106 East Center Street (now Lincoln Avenue). The building housed many businesses, including Bruce's Candy Kitchen and Public Library, L. E. Hardware, Staple Hardware, Crockery Glassware Tinware Agateware, Pacific Lodging House, C. H. Schaefer Cabinet Maker, and the Anaheim Bakery. Pictured here, from left to right, are Louis E. Miller, E. P. Fowler, W. J. Newberry, Capt. Irwin Barr, John B. Rea, E. B. Merritt, Henry Kroeger, Cornelius Bruce, August Nagel, and J. P. Zeyn.

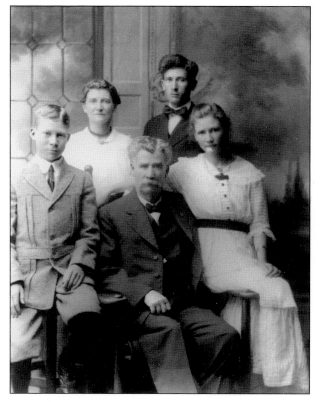

Judge James Solomon Howard was one of Anaheim's earliest photographers, a local realtor and justice of the peace. In this 1917 formal family portrait are youngest son James Howard, second wife, Minnie Schaefer Howard, eldest son Horace J. Howard, daughter Adele Howard, and the judge, who is seated in front.

Richard A. Melrose moved to Anaheim in 1870 when he was 22 years old. In 1872, with George C. Knox, he purchased the *Anaheim Gazette* and became the paper's third owners, publishing it until 1877. He served as Anaheim's postmaster in 1884, as well as the cty attorney. On January 17, 1887, Melrose was one of several businessmen to form a corporation known as the Anaheim Building and Improvement Society. In 1908, he was elected to the California Assembly from the 77th District. He passed away in 1924.

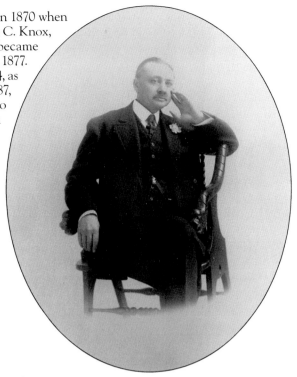

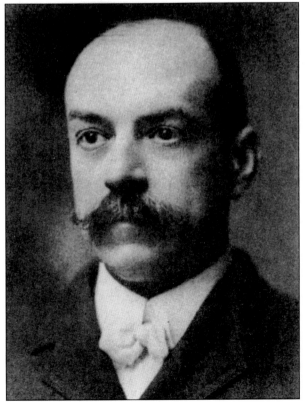

Henry Kuchel was the publisher of the *Anaheim Gazette* for 48 years (1887–1935). The eight-page weekly was published on Thursdays. He was the son of original Anaheim colonists Conrad and Samantha Quackenbush Kuchel. Henry was married in 1896 to Lutitia Bailey of Texas. Thomas H. Kuchel, their son, later became a United States senator.

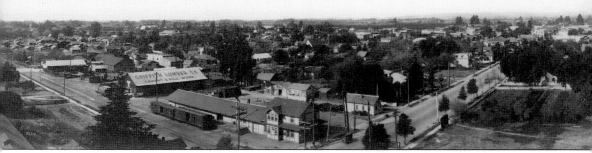

This 1913 panoramic photograph shows Anaheim from atop the 100-foot-tall water tower. In 1913, Judge James S. Howard carefully carried his large-view camera up to the top of Anaheim's landmark 100-foot-tall water tower to get this shot. From left to right are the Griffith Lumber Company mill along Santa Ana Street; the 1899 Southern Pacific Railroad Depot at Santa Ana

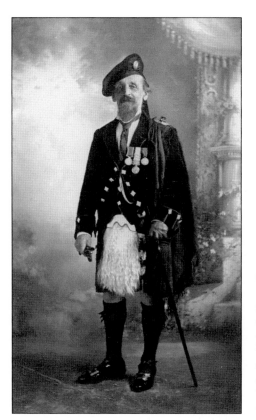

Capt. Alexander Henry arrived in Anaheim in 1867 and bought 220 acres near Lincoln and Brookhurst Avenues. After the 1886 vine disease devastated his grapes, he replanted his property, which he named "Caledonia Grove," with citrus and began making orange brandy. Captain Henry, a native of Scotland, was a decorated British veteran of the Crimean War. This c. 1867 formal portrait shows him in his military dress uniform.

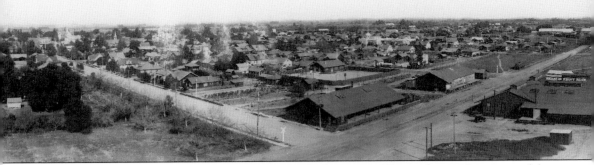

and Los Angeles Street (now Anaheim Boulevard); the Koenig Winery lot, in the center of the photo; Claudina Street, above Santa Ana Street; the tall Central School building, in the center of the background; and the newly built Broadway School at Olive and Broadway, at center right.

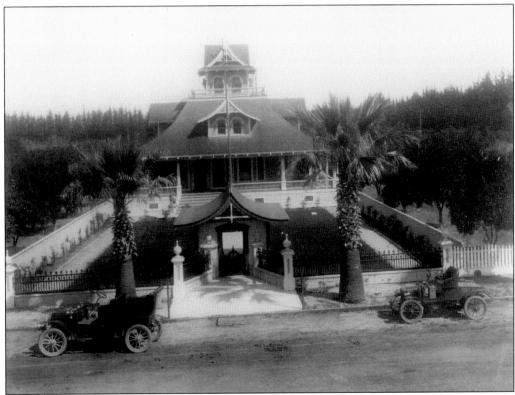

Pictured is the Alexander Henry residence at 1881 West Lincoln Avenue (formerly County Road). This very tidy residence, once described as a novelty in Roman and Egyptian design, was built in 1905. Henry later sold it in 1909, and it was razed in 1937.

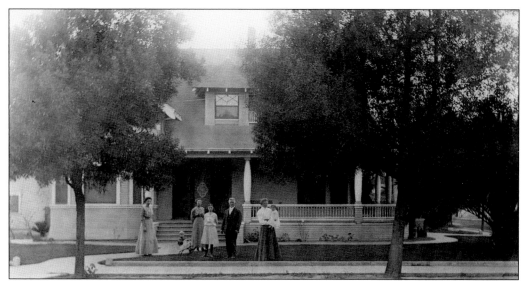

Ferdinand Backs, one of Anaheim's prominent businessmen, built this Colonial Revival home in 1902 at 225 North Claudina Street. Ferdinand arrived in Anaheim in 1867 and opened its first furniture store and undertaking parlor. His wife, Louisa Werder Backs, was a member of one of Anaheim's founding families when the Werder family came to Anaheim in 1859. Louisa raised their seven children in this stately home. The home was relocated to 188 N. Vintage Lane in 1987.

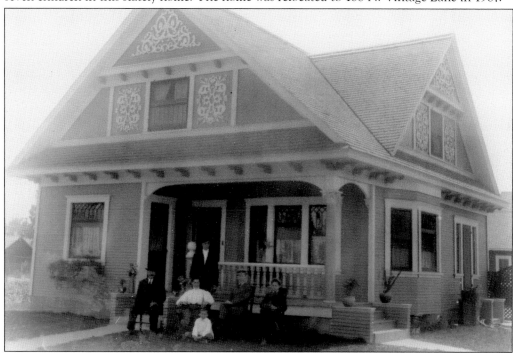

Ferdinand and Emma Heying's elegant Classical Revival–style residence, pictured here in 1908, was located at 127 North Olive Street. Originally from Missouri, Ferdinand was a local rancher who arrived in Anaheim in 1902 with his family. The couple's sons Alfred and Oscar opened Anaheim's Heying Brothers Pharmacy in 1910 and continued in business until 1960. Oscar served on Anaheim's city council from 1945 through 1954.

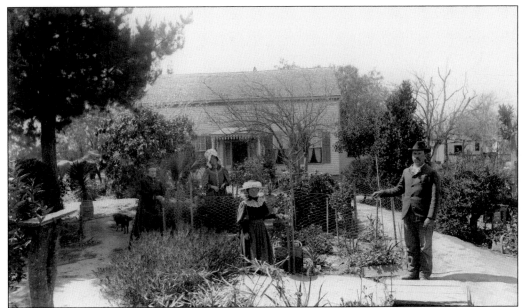

This was the home of Alfred and Alma Eymann Pellegrin, which was located at 525 North Citron Street. The residence was said to be the second oldest house in Anaheim. Pictured, from left to right, are Amalie Hammes Fröhling Eymann, Alma's mother; Alma Pellegrin; Pansy Pellegrin Van Oost, Alma's daughter; and John Eymann, Alma's brother. Alfred Pellegrin had the first photographic studio in Anaheim in the mid-1880s. The house was destroyed by fire in 1933.

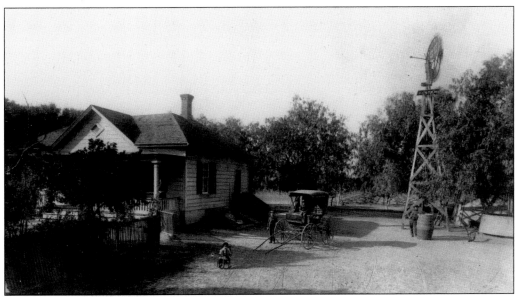

Dietrich Strodthoff immigrated to America from Hanover, Germany. In 1863, at age 24, he planted this 20-acre vineyard at the southwest corner of Lemon and North Streets. In 1864, he was appointed as the *zanjero* (ditch tender for water canals) by the board of trustees of the Anaheim Water Company, at a rate of $70 per month.

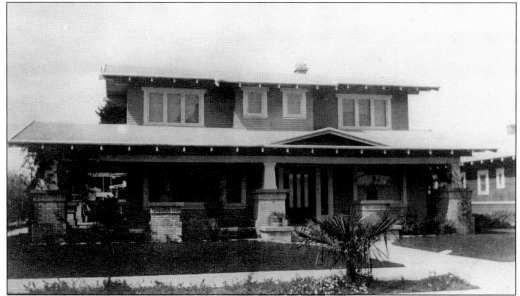

Robert Rimpau built this aeroplane/chalet-styled home at 503 North Zeyn Street in 1915. He was a descendent of Theodore Rimpau, one of Anaheim's founders.

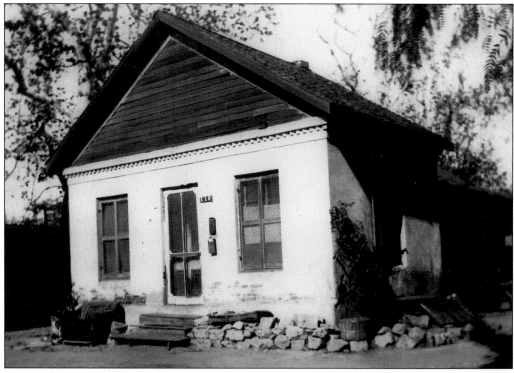

In its infancy, Anaheim had a significant Chinese population. The community's Chinatown was located around the 100 block of West Chartres Street. This 1940 photograph shows the last remaining Chinese dwelling, located at 119 West Chartres. Though they were dedicated workers who kept to themselves and maintained small businesses that catered to the locals, they were often the victims of local prejudice.

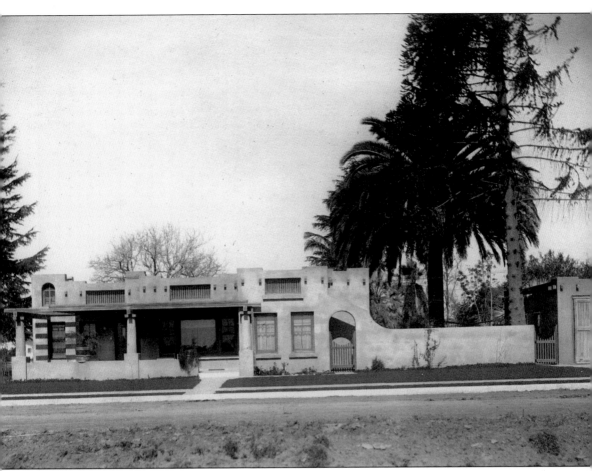

This handsome Pueblo Revival home was built for $8,000 in 1922 for Charles A. Boege, vice president of the First National Bank and Anaheim's city treasurer. The eldest son of one of Anaheim's pioneer families, Boege lived here with his wife, Louise, and two children. Long an Anaheim booster, he served the community faithfully as its treasurer. Unfortunately, by the mid-1930s, Louise's ill health and Charley's poor investments during the Depression had taken their toll. During the city's audit in July 1939, a shortage of $5,827.95 was traced to Anaheim's long-trusted treasurer. After tendering his resignation, a physically and emotionally broken Charles was led away to the Orange County Jail. After his death in 1945, no local obituary was ever published for him, the scandal still warm in the community's mind.

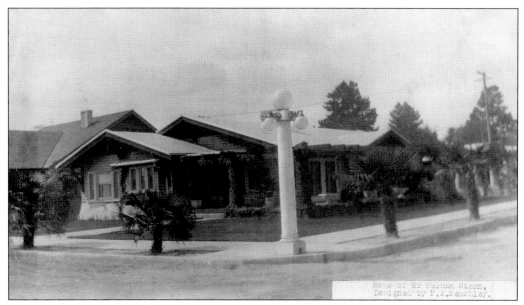

Anaheim businessman and civic booster Herman Stern built this Craftsman-style home at 521 North Zeyn Street. Long a proponent of community improvement, in 1915, while lobbying the city trustees for residential streetlights, Stern commissioned this temporary light at his street corner.

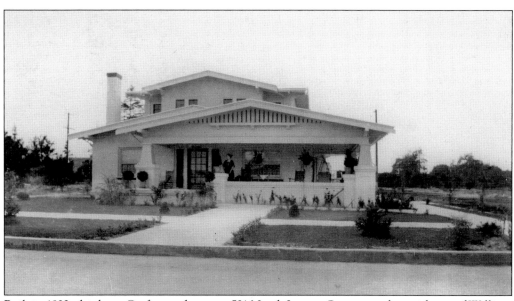

Built in 1922, this large Craftsman house at 521 North Lemon Street was the residence of William E. Duckworth, the son of Anaheim postmaster John W. Duckworth. William was a grocery and feed merchant whose business was located southwest of town. William was also involved in land development in Anaheim and was a member of the Degree of the Woodmen of the World. He sold this house to W. Newton Miller and his wife, Minnie, in 1924.

Four

CITRUS
A NEW BEGINNING

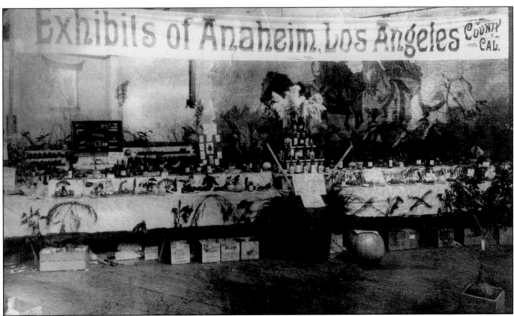

In 1886, the Southern California Citrus Fair was held in Chicago, Illinois. Anaheim, whose major industry was still winemaking at this time, promoted examples of the various fruits and vegetables that this area was producing. Dependable rail transportation was now bringing the fruits of Southern California eastward, and Anaheim's boosters wasted no time in making eastern buyers aware of the quality and variety of their agricultural prowess. By 1888, however, Anaheim's dependence on the grape would be forced to change, as Anaheim Disease was killing nearly every vine in the region. The hardy German growers quickly adapted to a variety of other crops that thrived in the region's mild Mediterranean climate.

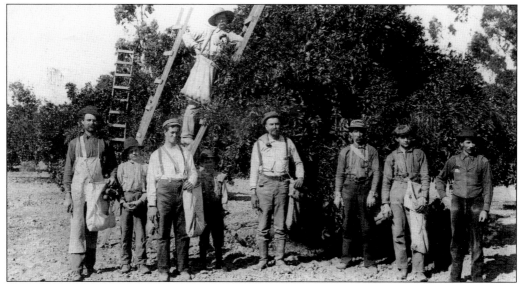

In 1899, nine orange pickers take a break for the camera's shutter at Theodore Rimpau's orange grove. Pictured, from left to right, are George Wells, Wells's son, Frank Jennings, Wells's younger son, Frank Clark (on ladder), Archie Cadman, George McAuley, William T. Wallop, and Billie Cooper. Anaheim Central Public Library now stands at the site of the Rimpau grove, at the corner of Broadway and South Palm (now Harbor Boulevard).

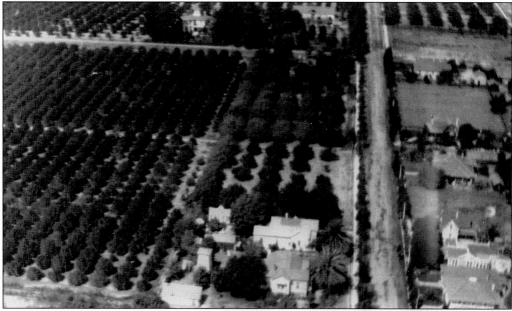

This turn-of-the-century aerial view shows the Langenberger property bounded by Lemon, Cypress, and Sycamore Streets. Taken from a balloon at the Anaheim Carnival, this view faces north, with Lemon Street on the right side of the picture. The Langenberger home, located at 223 West Sycamore Street, is at the top, left of center, surrounded by their ranch of Valencia orange groves. The two-story Turck home at 315 North Lemon and the one-story Herman Dickel residence at 309 North Lemon are seen at center, below. This area was developed as Anaheim's long-awaited city park (today's Pearson Park) in 1922.

46

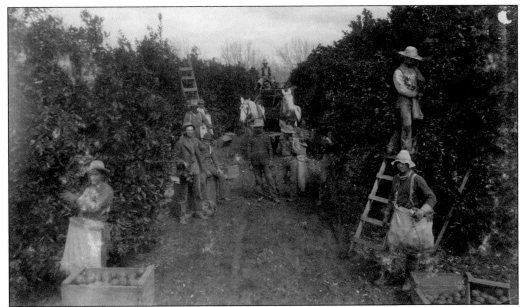

Once the significance of the grape blight settled in on the hardy vintners, a replacement for this important crop became of immediate importance. For some, the land boom of the 1880s permitted them a way to liquidate their landholdings. For others, the opportunity to carry on their agricultural livelihood came with the walnut, chili pepper, sugar beets, and, most importantly, the late-blooming Valencia orange. This turn-of-the-century view shows the agricultural laborers picking this important local crop.

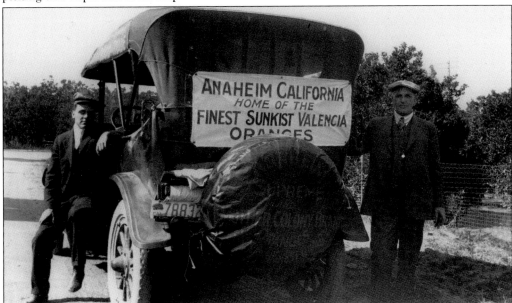

Anaheim orange growers took every opportunity to promote their Valencia orange crop. This 1915 photograph shows two boosters promoting "Anaheim, Home of the Finest Sunkist Valencia Oranges." By this time, the chamber of commerce was calling Anaheim the "Capital of the Valencia Orange Empire." One of the many packers in town, the Sunkist-affiliated Anaheim Citrus Fruit Association distributed the Anaheim Supreme and Mother Colony–brand Valencia oranges.

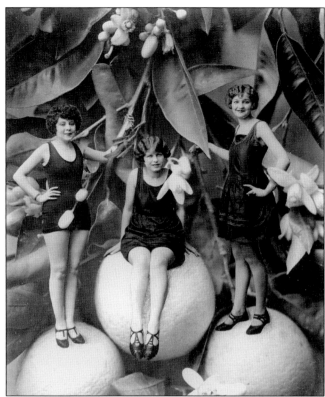

The California Valencia Orange Show was started by the Anaheim Chamber of Commerce to feature the area's most important product, the Valencia orange. The first show was opened on May 17, 1921, with a telephone address by Pres. Warren G. Harding, whose sister lived in nearby Santa Ana, and was held annually in Anaheim until 1931. This retouched publicity photograph shows three budding attractive models wearing period bathing suits standing among the blossoming fruit for which the event was named.

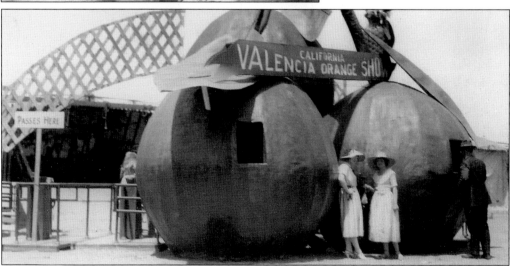

Beginning in 1921, the Anaheim Chamber of Commerce, in cooperation with the city, began the California Valencia Orange Show to "spread the fame, beauty and richness of the Valencia Orange." The 1921 event, held on a vacant lot on North Los Angeles Street, opened May 17 through a long-distance wire from the White House. A 50,000-square-foot tent housed the exhibits, which included units for citrus, automotive, industrial, and amusement. The Orange County population boom of the 1920s almost doubled Anaheim's population from 5,526 at the start of the decade to over 10,000 by 1930. Regional events such as the Orange Show and, later, the annual Halloween parade were used to advertise Anaheim as the best destination in Orange County.

The 1923 California Valencia Orange Show had an Egyptian theme and stylized figures, with an extensive use of fringe. Here is a peek inside a tent, whose exhibits and decor all contain Valencia oranges. The booth at right is decorated with Orange crate labels at its base. This event continued to gain popularity until 1931, when Anaheim's 10-year-old California Valencia Orange Show was combined into the Orange County Farm Bureau's Orange County Fair.

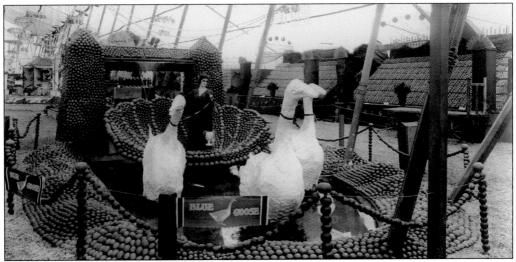

American Fruit Growers packed their citrus under the Blue Goose label. Their sweepstakes trophy-winning exhibit is pictured here during the 1923 California Valencia Orange Show. The attractive Miss Coleman is riding on a lily pad, constructed from oranges and pulled by three geese, all swimming in a lake made of the golden fruit. Chambers of commerce from Orange, Santa Ana, Redlands, Pomona, Pasadena, Los Angeles, and Corona joined Anaheim in planning this event that ran during the last week of May.

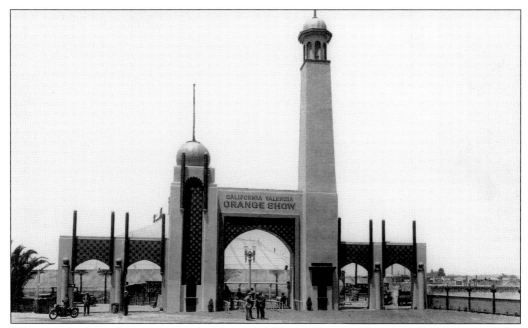

The success of Anaheim's inaugural California Valencia Orange Show in 1921 encouraged the chamber of commerce to make this an annual event. In 1923, the show moved to the North Anaheim area, where La Palma Park was eventually built. This large arched Moorish permanent entrance was built in 1925 and featured an 85-foot tower. Contests were held during these events, with prizes given for the quality of various exhibits as well as for the local packinghouse that had the fastest packer. The most popular exhibits were the automotive, where local auto dealers would exhibit their newest models to the delight of the visitors.

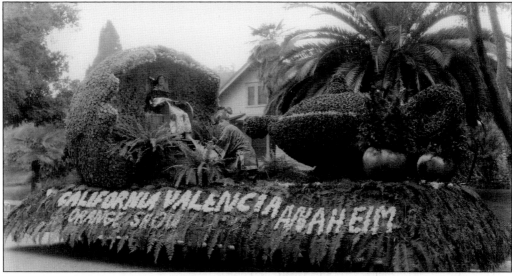

A parade through Anaheim's downtown opened the 1928 California Valencia Orange Show. Here is a view of the Anaheim float, decorated with a large Aladdin's lamp at the front. A contest was held to choose the queen of the show, pictured here riding on her throne with her consort kneeling before her. This year's show was held under a huge 400,000-square-foot tent and had close to 100,000 visitors during its 11-day run.

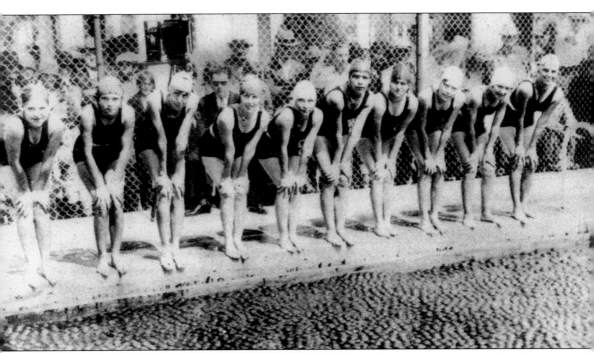

Jessie Darnley, a 16-year-old Anaheim High School athlete, swam her way to the title of Miss Anaheim in this unusual April 23, 1929 event. Darnley beat more than a score of contestants. Swimming 200 feet through three tons of Valencia oranges in the city park (today's Pearson Park) plunge earned her the right to represent the city at the California Valencia Orange Show, which opened its eighth year in Anaheim the following May.

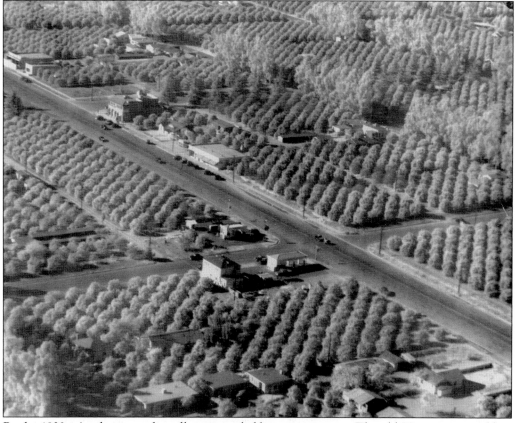

By the 1930s, Anaheim was literally surrounded by orange groves. The old 20-acre vineyard lots had long since been converted to orange culture. Seen here is the Fiscus property on South Los Angeles Street (now Anaheim Boulevard).

Anaheim's mild climate provided an ideal location for the citriculture that became its most important industry in the first half of the 20th century. Occasionally cold weather would fall on the community, and the orange ranchers would fire up their orchard heaters to take the chill off the groves. Burning waste oil, these smoky devices would be the bane of the housewife who happened to leave their wash hanging on a line overnight.

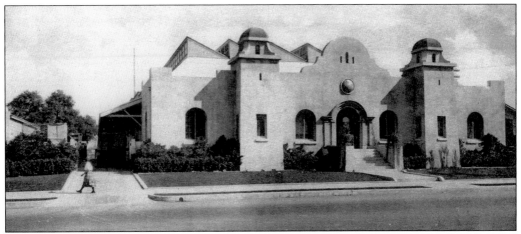

This Mission Revival–style, concrete orange packinghouse was built in 1919 at the corner of South Los Angeles Street (now Anaheim Boulevard) and Santa Ana Street. First opened as the Anaheim Orange and Lemon Association, its later reorganization resulted in the new name of the Anaheim Orange Association. The local chamber of commerce advertised Anaheim's Mediterranean micro clime as the "frostless belt." Anaheim was a dominant producer of the Valencia orange in the first half of the 20th century, packing over 5 million boxes by 1930.

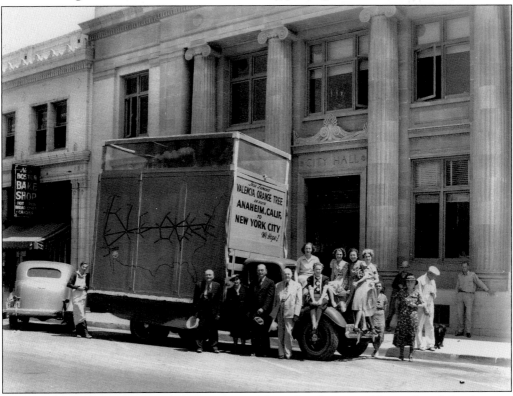

This 1936 view shows the chamber of commerce's latest local citrus publicity idea of planting one of Anaheim's famous Valencia orange trees in a truck and driving it to New York City. Mayor Charles Mann is pictured in front of the 1923 city hall, surrounded by Anaheim locals who wished the truck and its valuable contents good luck.

While Anaheim's mild climate made good fodder for the chamber of commerce, cold weather occasionally did visit the community. During the fall of 1937, freezing temperatures caused severe damage to the local Valencia citrus crop. Mr. Barfoot's grove at the corner of Vermont and South Los Angeles Street (now Anaheim Boulevard) used overhead sprinklers to water his acreage. When warned of the freeze, Barfoot turned on the sprinklers, which covered his orange groves in ice. This unusual tactic actually prevented the freezing damage to his grove. The local packinghouses had to install X-ray equipment and employed women to examine fruit through fluoroscopes to see if the fruit was frozen and crystallized.

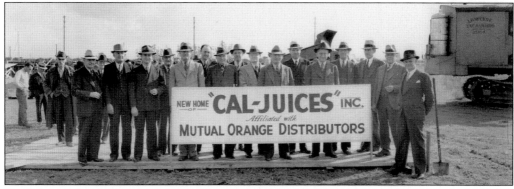

On February 1, 1938, ground was broken for Anaheim's new Cal-Juice plant, owned by Mutual Citrus Distributors (MOD), a major regional citrus fruit packer. Anaheim's economy at this time was still dependent upon citriculture, and this groundbreaking became a major civic event with over 200 guests. In attendance were officials from the City of Anaheim, the chamber of commerce, MOD, and the Union Pacific Railroad. Cal-Juice was a cooperative owned by the citrus growers, permitted to process orange juice concentrate rather than have their lower graded fruit discarded.

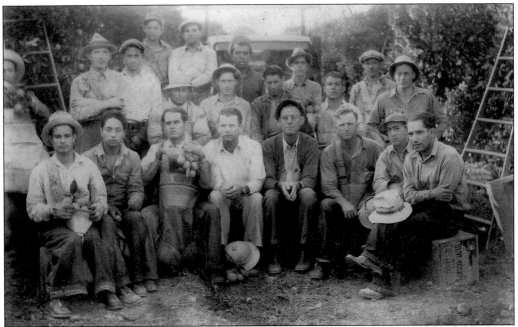

Citrus as Anaheim's major industry required the labor to maintain the groves and seasonally pick the fruit. This portrait shows one of the picking crews that provided fruit to Frank Belmont's Granada packinghouse. The Foreman, Saul Diaz (second row, second from right), who lived nearby, would drive his vehicle around town to pick up the crew and deliver them to the groves. The picking crews were made up of local residents and migrant workers. (Courtesy of Debbie Diaz Reiter.)

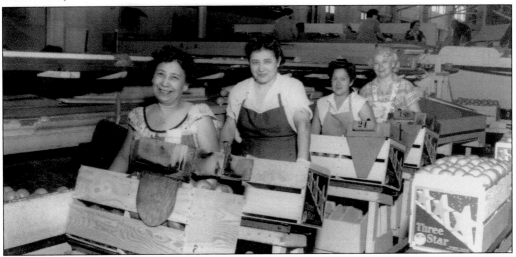

In 1938, the Valencia oranges peak in Orange County, 67,536 acres were planted, with production of over 9.3 million boxes, worth $16.9 million. Anaheim was home to a number of regional orange packing houses. Here we see the interior of the Orange Belt Fruit Distributors that was located at 805 East Center Street (now Lincoln Avenue). Women who worked seasonally for the firms generally handled the actual grading and packing of the fruit. Pictured here, from left to right, are Marcella Gomez, Chonita Veyna, and two unidentified women packing Orange Belt's Three Star brand.

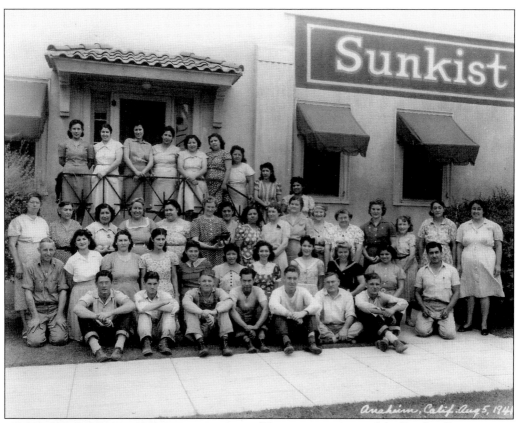

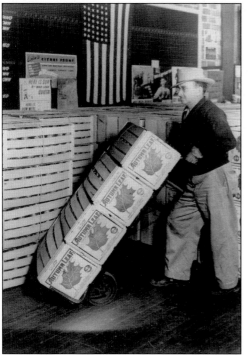

This group portrait of the Borden Fruit Company was taken on August 5, 1941. Borden Fruit was a Sunkist affiliate, the country's largest citrus co-op. Sunkist, whose history dates back to 1893 when a group of growers banded together as the Southern California Citrus Fruit Exchange, actually adopted the Sunkist trademark in 1908. Sunkist's cooperative partnership with the grower greatly lowered their financial risk and allowed greater control of the marketing of the fruit by the growers.

Anaheim Cooperative Orange Association was one of a number of local packinghouses that were owned by the growers themselves. This permitted the local orange rancher the opportunity to have control of their packing and marketing functions. Their large facility was located at 1530–1540 West Lincoln Avenue. This 1943 view (complete with the World War II patriotic addition of an American flag) shows Charles Reynolds moving crates of the co-op's Autumn Leaf brand.

Five

BUSINESS AND CIVIC GROWTH

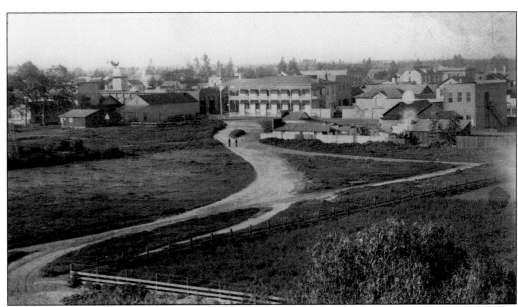

Pictured from the tower of Central School, this view looks toward Anaheim's east. The two-story Planters Hotel is at center, surrounded by Anaheim homes and businesses. Anaheim colonist and its first postmaster, John Fischer, constructed this large hotel in 1865 at the corner of Center Street (now Lincoln Avenue) and Los Angeles Street (now Anaheim Boulevard). It burned down in 1865 and was soon rebuilt but was again lost to fire in 1890.

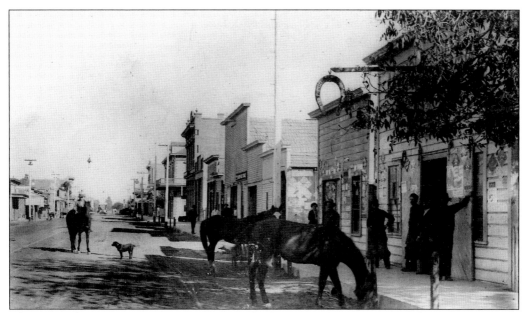

This late-19th-century scene of Center Street, looking east, shows Fred Pressel's Blacksmith Shop at 218 West Center on the right and the tracks of the Anaheim Street Car Company running in the center of the street.

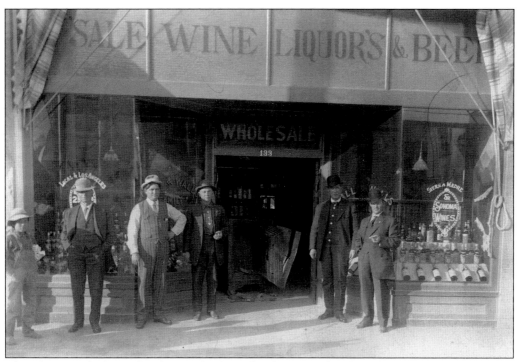

This photograph shows the shattered safe in the doorway of Hall and Walls Wholesale Liquor store resulting from a burglary on December 18, 1910. John W. Walls operated this wholesale firm at 133 West Center Street (today's Lincoln Avenue) and specializing in local and regional wine, liquors, and beers.

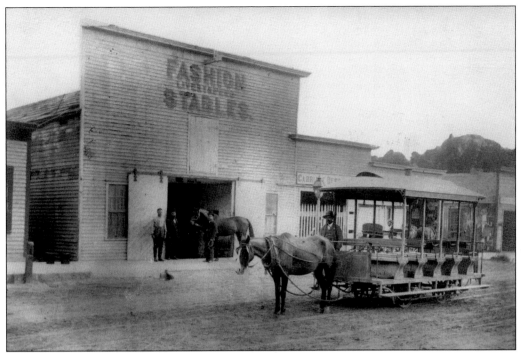

Lafayette F. Lewis, a native of New York, moved to Anaheim in 1872 and established the Fashion Stables on Center Street (now Lincoln Avenue). Anaheim's first mayor, Max Von Strobel, incorporated the streetcar line, but his death in 1873 stalled construction until 1887. The line finally opened in March, but operations barely covered expenses during its years of operation. Orange County's second horsecar line quietly closed in 1899, and the tracks were removed in 1901.

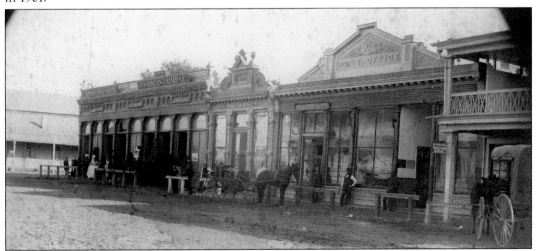

In 1885, Center Street (today's Lincoln Avenue), pictured here looking west from the intersection of Los Angeles Street (now Anaheim Boulevard), was the center of Anaheim's business district. Visible are a number of pioneering business firms, such as Hippolyte Cahen, Goodman and Rimpau, Bank of Anaheim (dated 1882 in the stone cornice), Pelligrin and Son (watchmakers and photographic studio), the post office, Hanna and Keith Real Estate, and the Western Union Telegraph Office.

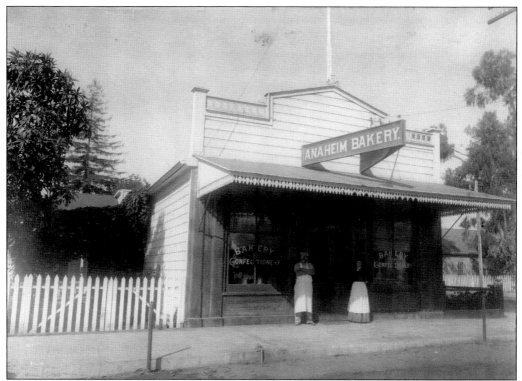

Peter Syre and his wife, Louise, are seen standing in front of their Anaheim Bakery and Confectionery in this 1908 scene. The business, located at 233 North Los Angeles Street (today's Anaheim Boulevard), supplied fresh baked goods to the growing community in the first decades of the 20th century.

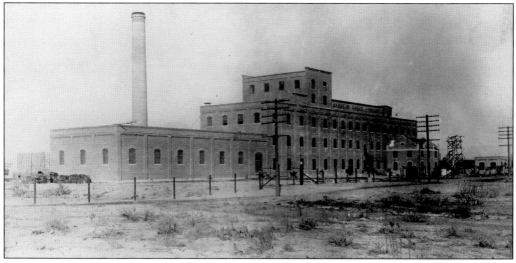

The most substantial industrial building in Anaheim in the early 20th century was the Anaheim Sugar Factory building just north of the city limits. Built in 1910 to serve the local sugar beet industry, it was an impressive three-story brick structure that had its own water wells and electric generation. It was later purchased by the Holly Sugar Company and was used seasonally until 1920, when the plant was finally closed and the equipment moved to Sidney, Montana.

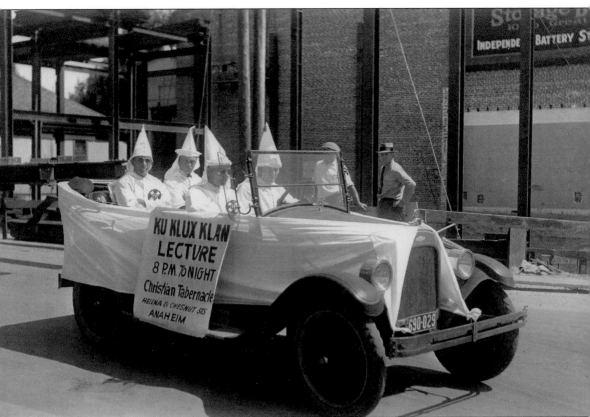

The boom times of the twenties for Anaheim had a dark side as well. The Ku Klux Klan had begun to recruit members in many cities of Southern California and by 1924 claimed they had 1,400 members in their Anaheim chapter. Rather than resort to the vigilante tactics that the Klan used in the Deep South, they grew their political influence here by electing three city council members in 1924. They had an eloquent spokesman, Rev. Leon L. Myers of the local First Christian Church, who was the foremost figure in organizing the local Klavern of the Invisible Empire. A July 29, 1924, KKK rally that drew 10,000 onlookers to the city park to see 1,000 candidates initiated also galvanized the community against the anti-Catholic, anti-Latino, and anti-bootlegger aims of the hooded throng. The fledgling *Anaheim Bulletin* newspaper took a strong stand against the Klan and published a list of known members on their front page in open defiance of the intimidation that was being used against the publisher, Lotus "Gov" Loudon. Finally, a February 3, 1925, recall election ousted the four city council members that supported the KKK as well as most of the city's police, who were also reportedly members. The wounds of this sad time in Anaheim's otherwise "boosterish" 1920s were felt for many decades thereafter.

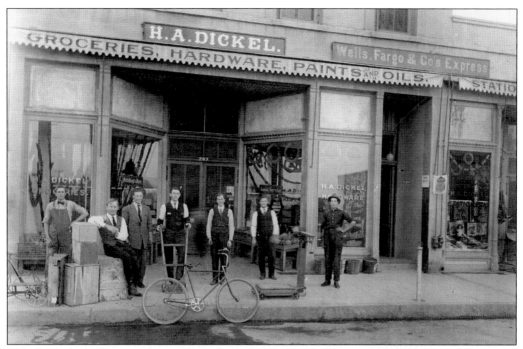

This December 1910 view shows the H. A. Dickel Hardware Store and Wells Fargo and Company Express building, which were located at 202 West Center Street (today's Lincoln Avenue). Originally built by Anaheim pioneer August Langenberger in 1875, this building housed the Dickel Store for many years until it was razed in 1925 to make way for the SQR store. From left to right are Walter Neipp, Frank Tausch, Walter Mickle, Bill Wallop, Frank Perry, Fred Schneider, and Charles Jester.

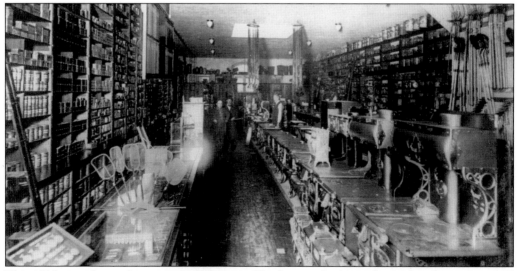

This 1915 view shows the interior of Martenet Hardware, which was located at this time at 125 West Center Street (now Lincoln Avenue). Morris Wampler Martenet Sr. is in the background at right, behind the row of wood burning stoves. His store was well known for the selection of the heavy stoves and other products that the growing town required. His son Morris "Morrie" W. Martenet Jr., who inherited the business, served as a city councilman from 1932 until 1942.

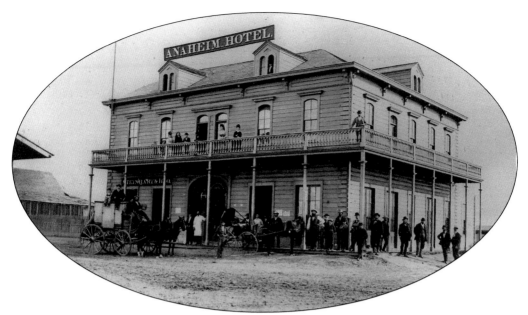

One of the original colonists and Anaheim's second mayor, Henry Kroeger built the Anaheim Hotel at the corner of West Center (today's Lincoln Avenue) and Lemon Streets in 1856. It was later sold to Max Nebelung, the hotel's proprietor and a respected civic leader. This was one of Anaheim's popular hostelries until it was replaced by the Valencia Hotel in 1916.

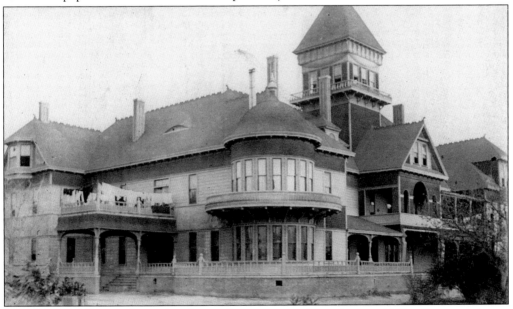

The Hotel Del Campo, located at the northeast corner of Broadway and Olive Street, took two years to build (from 1888 until 1890), due to the scarcity of lumber. Although built and furnished with quality materials, the fortunes of this hostelry were bleak. Financial setbacks resulted in the hotel's closure and conversion into the Pacific Sanitarium and School of Osteopathy in 1896. The hotel's brief career ended in 1905, when the property was sold for $8,000 and the building razed. The 300,000 board feet of serviceable lumber were used to build a number of homes in early Anaheim.

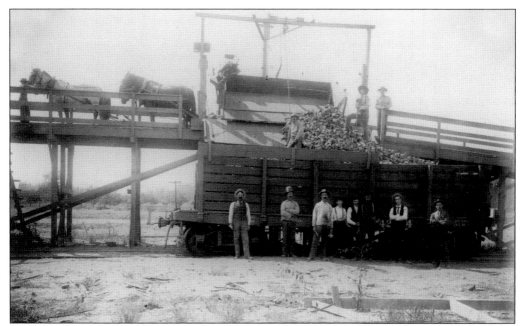

Timothy Carroll, an Irishman who settled in Anaheim in 1863, started the Evergreen Nursery, a firm that supplied most of early Anaheim's citrus, pine, palm, and vegetable rootstock. In addition, he owned 500 acres of land in West Anaheim, where he raised alfalfa and fruit trees. Carroll was an inventor with a number of patented machines in his name. The one pictured here in the West Anaheim area in 1898 was the "Carroll Patented Beet Dump."

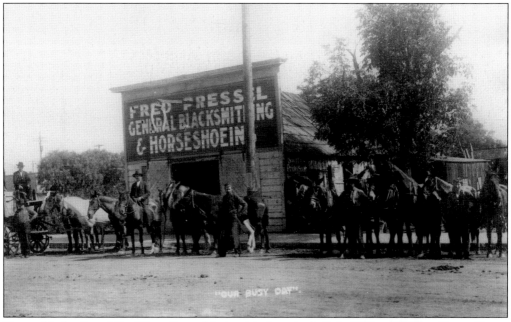

Pictured is the first of Fred Pressel's two blacksmith shops he built in 1895 at 218 West Center Street (today's Lincoln Avenue). The structure served the community's blacksmithing, horseshoeing, and general repair needs for many years. The Pressel family stayed active in the civic life of Anaheim and continued to operate a well-respected hardware store well into the late 20th century.

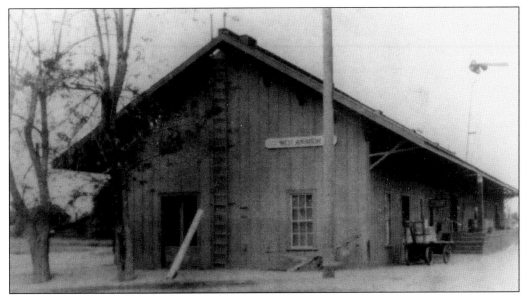

Timm John Fredrick Boege arrived in Anaheim from Holstein, Germany in 1861 and purchased a quarter section of land southwest of town from the Stearn's Rancho Company. In order to quell the opposition to the arrival of the Southern Pacific Railroad to the area in 1875, he donated forty acres for the right-of-way and station. This 1875 depot, originally called the Anaheim Station, was later renamed Loara Station and lastly, West Anaheim Station in 1907. The arrival of the railroad finally provided efficient transportation for the residents and more importantly, the area's agricultural products.

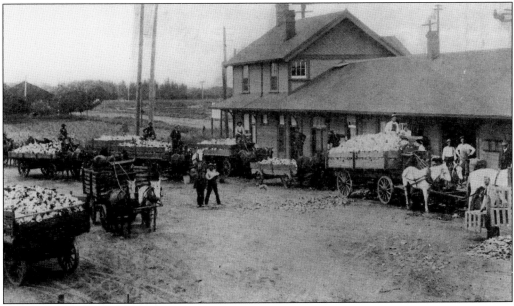

Horse-drawn wagons of cabbage are being delivered to Anaheim's second Southern Pacific Depot at the corner of South Los Angeles Street (now Anaheim Boulevard) and Santa Ana Street. This "Standard No. 23" Depot was built in 1899, when the railroad built a cut-off through south central Anaheim to better serve the new packinghouses that were locating there. It served the community until 1958.

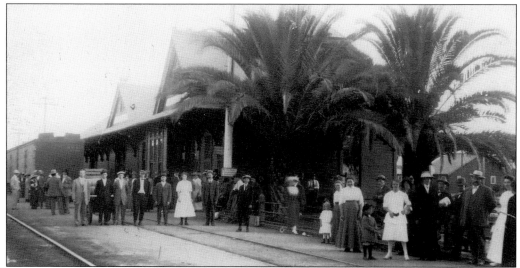

The Santa Fe Railway entered Anaheim in 1888 with this wood-frame station located at 708 East Center Street (now Lincoln Avenue). The second railroad serving the town, it provided competition to the Southern Pacific, which entered Anaheim in 1875. The competition between the two railroads spawned a rate war that ignited a regional real estate boom, complete with speculators, paper cities, brass bands, and free lunches for prospective land investors.

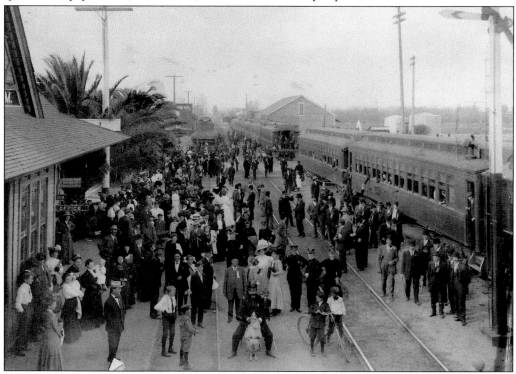

On February 13, 1910, this Santa Fe train was chartered by Anaheim Lodge No. 105, Knights of Pythias to bring 1,500 members from the Los Angeles area to Anaheim for the initiation of 118 new members into the Anaheim lodge. One of the local Knights is pictured meeting the train and his fellow brothers by riding a goat.

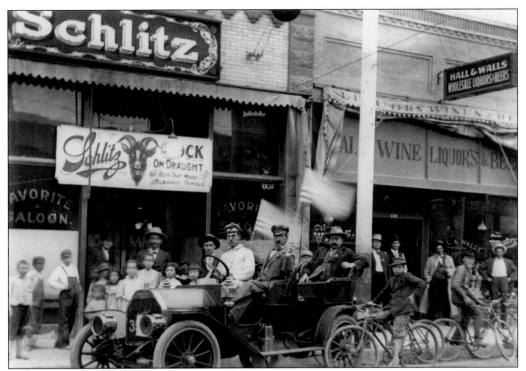

This *c.* 1908 photograph shows Roman Wisser's "Favorite Saloon," located on West Center Street (now Lincoln Avenue). After Roman's death, his son Lucien "Pete" continued with the family business. In 1920, Prohibition forced the family to convert the space into a sporting goods store, which supplied many Anaheim children with their first BB guns, pocketknives, and bicycles.

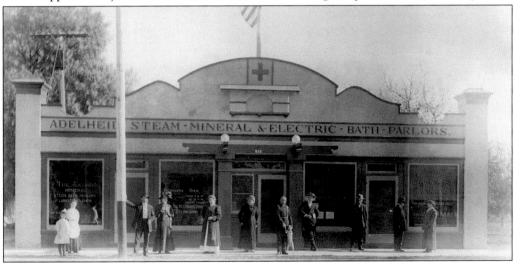

In 1858, William Koenig of Hanover, Germany, arrived in San Francisco, where Anaheim's largest vintner, John Fröhling, hired him to run his winery interests in Los Angeles. Koenig moved to Anaheim in 1868 and began a winery of his own. After his death in 1911, Koenig's wife, Adelheid Eichler Koenig, continued to operate a number of his businesses, including the Adelheid Steam-Mineral and Electric Bath Parlor, located at 212 South Los Angeles Street (later Anaheim Boulevard). Adelheid is fifth from the left in this 1916 photograph.

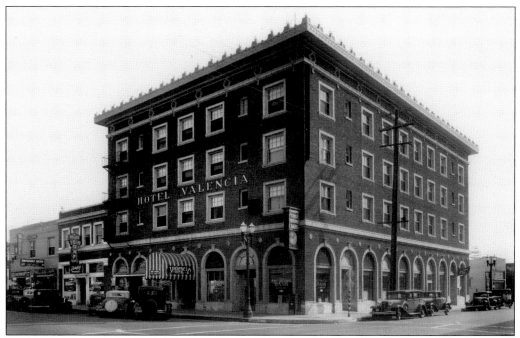

John B. Ziegler built Anaheim's Valencia Hotel in 1916 on the site of two previous hotels, the Anaheim Hotel and the Commercial Hotel. Located at 182 West Center Street (now Lincoln Avenue), at Lemon Street, the new $40,000 brick hostelry was designed by local architect M. Eugene Durfee. When this mid-1930s photograph was taken, the First National Bank was the first-floor tenant.

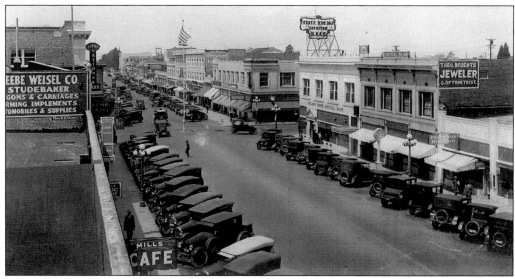

This 1923 view of East Center Street (now Lincoln Avenue) shows Anaheim's bustling business district. The flagpole in the center of the intersection marks Los Angeles Street (now Anaheim Boulevard), the center of the city. Pictured along the south side of Center Street are the Mills Café, Cherry Blossom Confectionery, Weber's Book and Music Store, Mullinix Drug Store, and the First National Bank. On the north side, identifiable businesses are the Hotel Antlers, Golden State National Bank, and the Central Building.

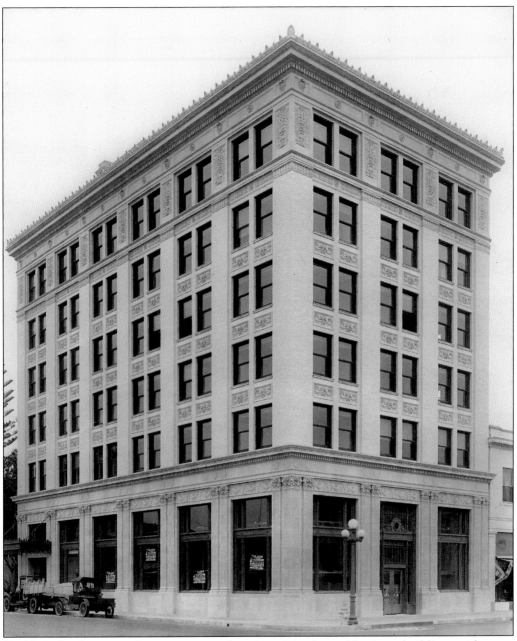

By 1915, Anaheim was beginning to replace its original wood business buildings with more substantial brick structures. Samuel Kraemer, one of Orange County's influential citizens, developed much of downtown Anaheim in the 1920s, including his six-story American Savings Bank of Anaheim. Designed by local architect M. Eugene Durfee, it was built at the same time that Charles C. Chapman was building his "skyscraper" in nearby Fullerton. When Kraemer became aware that the Chapman building was going to be five stories, he had Durfee add an additional story and a penthouse so his building would be the tallest in Orange County. It remained so for over four decades. This excellent example of Renaissance Revival architecture survives today as the last example of Anaheim's building boom of the twenties.

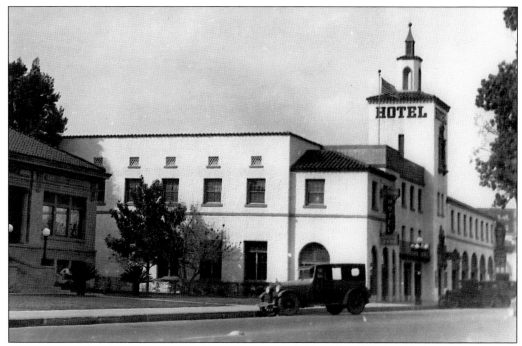

The Pickwick Hotel was located at 225 South Los Angeles Street (now Anaheim Boulevard), adjacent to Anaheim's 1908 Carnegie Library. The Pickwick Motor Transit Companies originally built this $110,000 hotel as the El Torre in 1926. Pickwick maintained its bus station on the first floor of the building, which also housed a number of small businesses. It survived the Long Beach earthquake of 1933 and continued to serve the community in a variety of roles until its demolition in 1988.

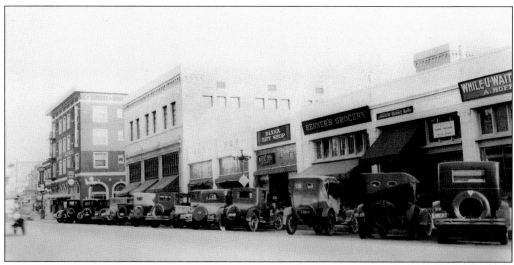

This late-1920s view of West Center Street (now Lincoln Avenue) shows the SQR store (center), one of early Orange County's premier department stores. The store's third and final location was here at 202 West Center Street. Originally opened by the Schumacher, Quarton, and Renner families, this store catered to the clothing needs of Anaheim's upscale shopper.

This *c.* 1899 photograph shows Anaheim's second city hall building, located at 202 East Center Street (today's Lincoln Avenue). This two-story structure, built in 1892, also housed the police and fire departments. This building replaced Anaheim's pioneer three-room city hall and jail, built on West Cypress Street, in 1870.

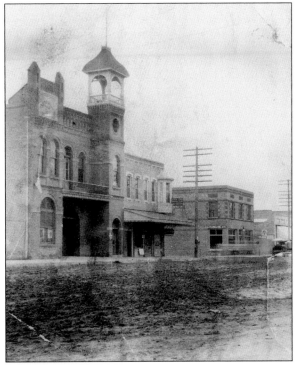

Anaheim's thrifty civic leaders began their municipally owned water department in 1879, as much to defray the cost of sprinkling the dusty streets of town, as to generate a small income for the community. The original facilities included a shallow well, a steam-driven pump, and a 20,000-gallon redwood tank. This October 1891 photograph shows the firm of Wille and Albrecht installing a new 60,000-gallon tank to serve the growing town.

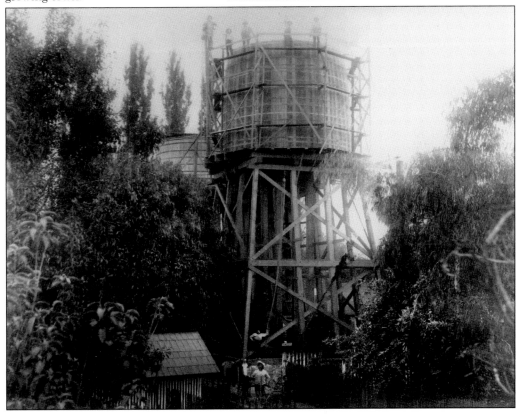

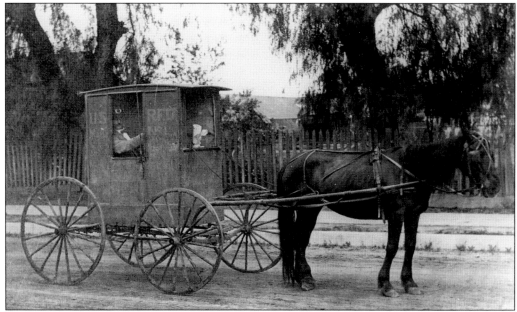

One of Anaheim's earliest mail carriers, Frank Eastman is pictured here in 1898 in his Rural Free Delivery (RFD) horse-drawn mail carriage. Eastman was carrier for Route 1, which covered most of the community at the time. Before building this homemade four-wheeled carriage, Frank covered the route on foot.

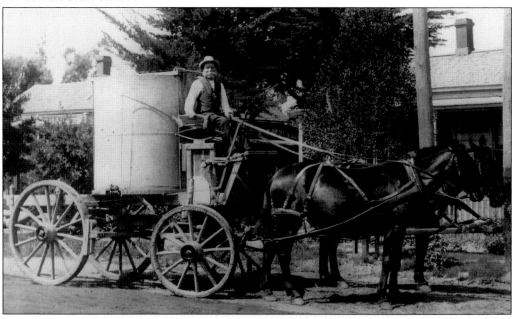

From 1902 to 1913, Rudolph "Rudy" Fossek was contracted by the city trustees to sprinkle the dusty streets of Anaheim. This 1902 view shows Rudy and his new horse-drawn 700-gallon sprinkler wagon, preparing for another day's work. Rudy also accompanied Anaheim's volunteer firemen to local blazes to provide an auxiliary water supply. By 1913, the community finally convinced the frugal trustees to pave the main streets of the town, rendering the sprinkler wagon and Rudy's employment unnecessary.

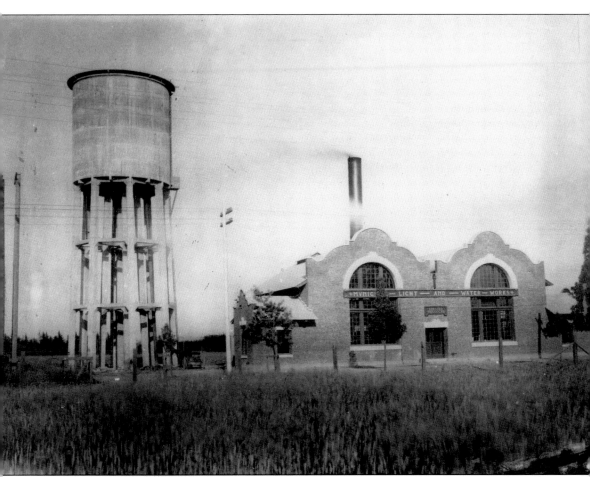

At the beginning of the 20th century, Anaheim's growth stretched the capacity of its pioneer water and electric works on Cypress Street well beyond capacity. In a special election held April 14, 1906, Anaheim residents voted to indebt themselves in the amount of $46,000 to construct additions to both facilities. A new four-acre site for both municipal works at 518 South Los Angeles Street (now Anaheim Boulevard) was later purchased for $1,200. In 1907, after much debate, a 175,000-gallon reinforced concrete water tower, the first of its type in the West, was constructed. It was in service by October 1907 and was soon followed by the construction of Anaheim's new powerhouse, which began service on December 20, 1907.

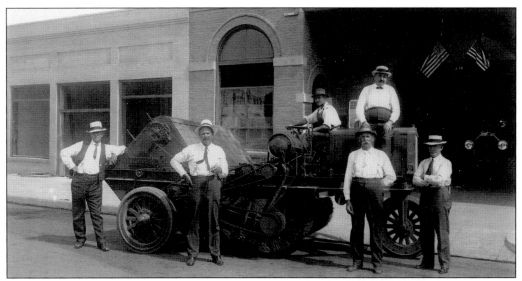

By the mid-1910s, Anaheim had begun to pave its main streets, finally eliminating the dusty thoroughfares long complained about by the street-side businessmen. In this 1914 photograph, Anaheim's new Elgin Motor Sweeper is parked in front of city hall. Pictured, from left to right, are Bill Sackett, Mayor John Cook, and councilmen John Brunsworth and Charles Mann. Sitting on the sweeper is Bud Sackett, street superintendent; and Bill Stark.

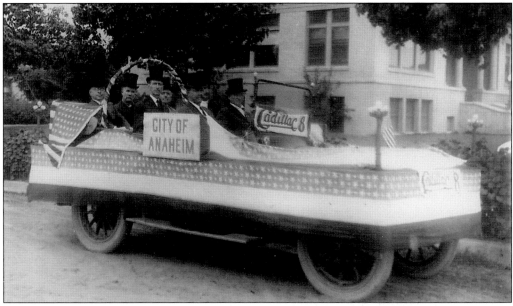

Anaheim residents had demanded improved street lighting since the town began the first municipally run electric system in Orange County in 1895. Cost and who would pay for the proposed ornamental lights always stalled the idea. Finally, a method was agreed upon wherein property owners would be assessed toward the cost of the lighting installation. The inauguration of the new system on Thursday evening, June 17, 1915, saw "thousands" viewing the new lights. This photograph shows Judge J. S. Howard, city manager O. E. Steward, and Anaheim mayor John Cook riding in a Cadillac 8, festooned with miniature examples of the new five-headed ornamental lights.

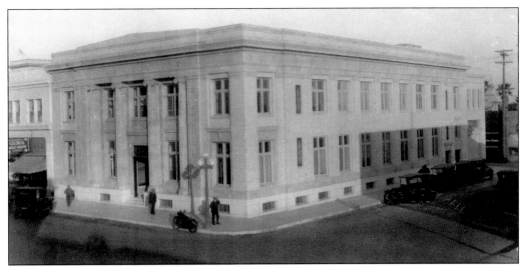

Anaheim's third city hall was located at 204 East Center Street (now Lincoln Avenue) and Claudina Street. This proud two-story, brick-and-marble structure, built in 1923, housed Anaheim's seat of government as well as the fire and police departments. This fondly remembered structure served the community until downtown redevelopment required its razing in 1980.

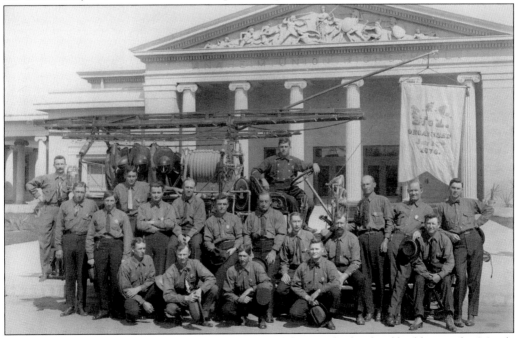

Anaheim's volunteer fire department poses in front of the 1912 high school building in this March 26, 1916, view. Organized in July 1878, the volunteers were called out to protect the community whenever the powerhouse alarm siren sounded. Almost all of these men were civic or business leaders who took their commitment to the town seriously. Pictured, from left to right, are (first row) Herman Backs, Fred Backs, Burley Goodrich, Fred Schneider, and Herman Schindler; (second row) Walter Clark, Carl Pressel, Leslie Swope, Robert Quarton, Charley Clark, Herman Stock, Al Erickson, Elmer Goodrich, Joe Gibson, Frank Tausch, and Al Nowotny; (third row) Richard Fischle, Frank Goodrich, and Conrad Mauerhan (at the wheel).

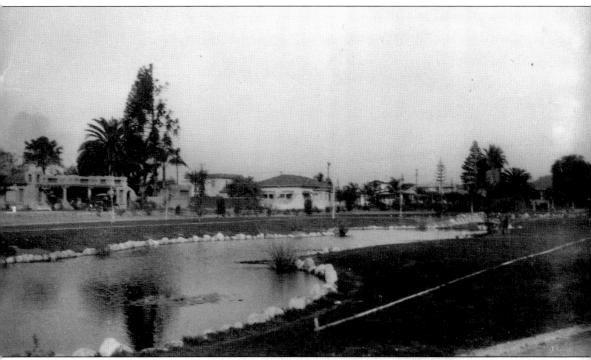

"After many years of disputes, bickerings and vain attempts, the people of Anaheim appear to have buried the hatchet and henceforth will work in harmony for civic improvements," wrote the *Anaheim Gazette* on October 7, 1920. The editor reported that the thrifty voters finally approved a $100,000 bond issue to buy a 20-acre tract for $70,000 for the site of a long-awaited city park. By the end of the 1920s, Anaheim was known locally as the "City with the Beautiful Park," a fact not lost by its chamber of commerce, who often boasted this major civic improvement. Goldfish filled lagoons, a lighted softball diamond, tennis courts, picnic grounds, an Olympic-size swimming pool, and an open-air amphitheater seating 2,000 provided the community with an important cultural and recreation venue.

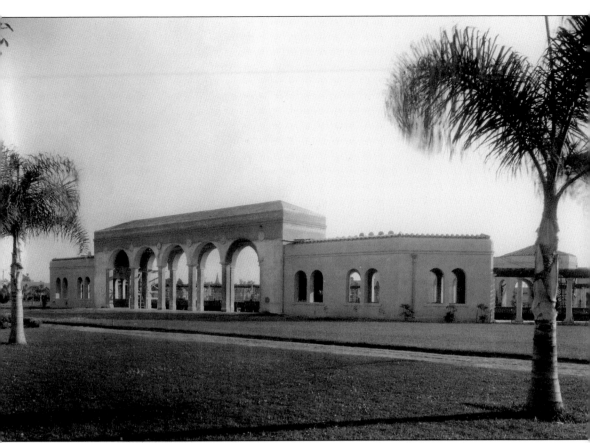

Long known to Anaheim residents as the Greek Theater, today's Pearson Park Theater was dedicated to the community on July 15, 1927. This photograph shows the still-unfinished building swathed in scaffolding and draped in patriotic bunting, in preparation for the opening ceremonies. Once the property of the Bullard, Turck, and Dickel families, the 20-acre park would finally realize the goal of Anaheim leaders who had discussed the need for a public park since the town's earliest days. Local architect M. Eugene Durfee, who prepared plans for many Anaheim business buildings, also designed this $35,000 open-air amphitheater.

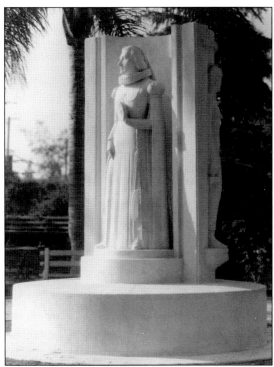

On September 15, 1935, this statue of Madame Helena Modjeska, a Polish patriot and renowned actress, was dedicated in Anaheim's city park (today's Pearson Park). Modjeska emigrated with her husband, Count Bozenta Chlapowski, to the United States in 1876, originally locating in Anaheim. This $15,000 statue designed by artist Eugen Maier-Krieg and funded by the Anaheim Rotary Club, the City of Anaheim, and Federal Public Works of Art Project, is the oldest example of public art in Orange County.

Charles Rudolph "Rudy" Boysen, a self-schooled botanist, created the hybrid berry that bears his name, in the Napa region of California in 1925. Unable to make a commercial success of this discovery, Boysen moved to Anaheim with his wife, Margaret, and young son Robert to be closer to Margaret's parents. In 1932, Rudy gave a few of his surviving berry vines to Walter Knott, a local berry grower in nearby Buena Park. At the time, Boysen was employed by the city as its park superintendent, and had lost interest in his berry. Knott went on to make a commercial success of Boysen's discovery, while Rudy is best remembered for the horticultural development of what is today known as Pearson Park. This late-1930s photograph shows him building the cactus garden that contained a number of very rare varieties of the desert plant.

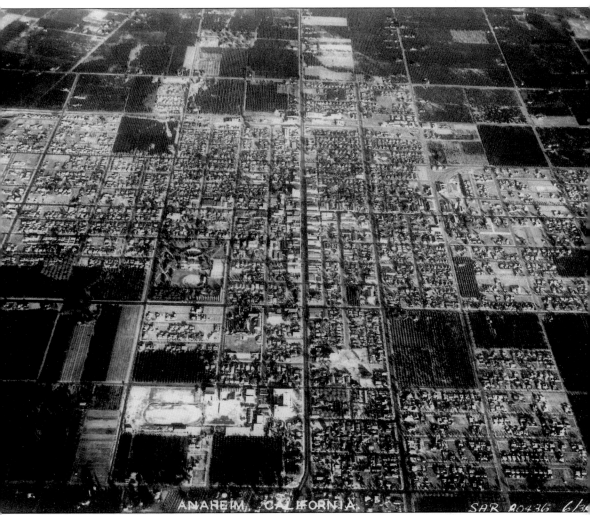

ANAHEIM, CALIFORNIA. SAR 20436 6/3

This June 1938 aerial view of Anaheim looks east from West Street. Center Street (today's Lincoln Avenue) runs through the center of the photograph, past East Street. Anaheim Union High School and its quarter-mile track are visible at center below, with the city park (today's Pearson Park) at center left. The numbers of orange groves that surround the town show Anaheim's dependence on citriculture at this time.

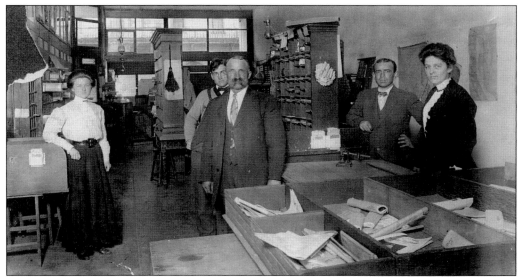

John W. Duckworth served as Anaheim's postmaster from 1906 to 1914. This 1911 view of the inside of the post office shows, from left to right, postal workers Madeline Whitaker Maas, George Chambers, Postmaster Duckworth, Assistant Postmaster Elmer Imus, and money order clerk Alice Robison Scott. This facility at 134 West Center Street (now Lincoln Avenue) served the postal needs of the community until a new modern building was constructed in 1936.

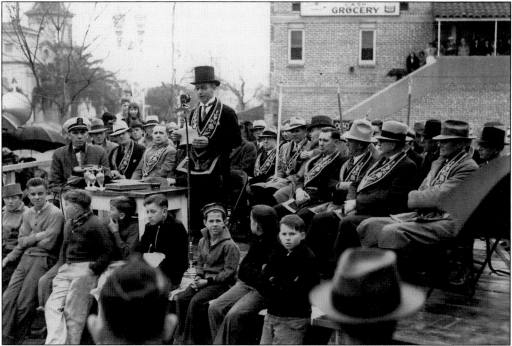

On May 29, 1936, Anaheim finally broke ground for its new $86,000 post office at 121 West Broadway, with a full Masonic ceremony. The modern concrete building replaced the venerable old postal facility at 134 West Center Street. The Broadway site had finally been chosen after a number of years of discussion, negotiating, and political patronage issues were resolved with the federal government. The building was heavily remodeled in 1970 and demolished in 1996.

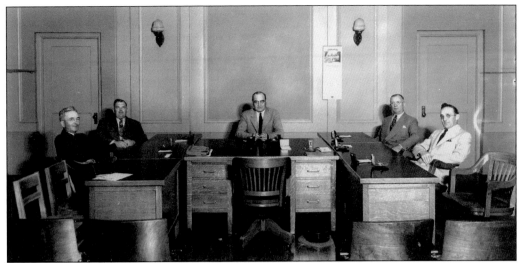

Anaheim's elected leaders are pictured in 1937 in the city council chambers. From left to right are Leo J. Sheridan (secretary of the Anaheim Union Water Company), Charles Pearson (future Anaheim mayor), Mayor Charles H. Mann (local auto dealer), Frederick "Fritz" Yungbluth (local businessman), and Morris W. Martenet Jr. (local businessman). In eight months, they would lead Anaheim through its largest disaster, the March 3, 1938, flood.

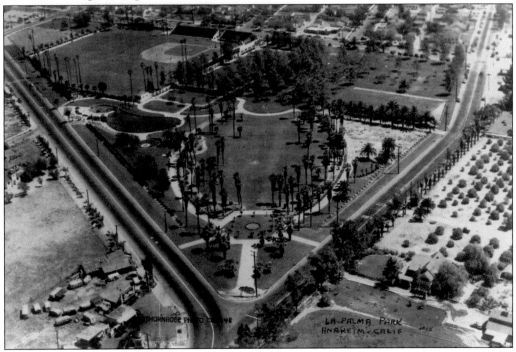

Anaheim started discussing a second public park in 1935. A location at the north entrance to the city was arranged and the name La Palma Park was chosen by a public lottery. After several years of delays, including the March 3, 1938, flood that ruined the work that had been accomplished to date, the city finally dedicated its new civic asset on Saturday, August 4, 1939. The park acted as the spring training grounds for the Philadelphia Athletics (1940–1943), and the St. Louis Browns (1946).

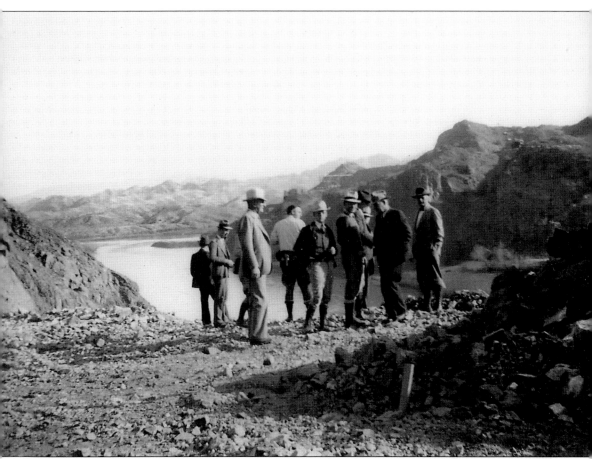

As citriculture replaced viticulture, the demand for water outstripped the Santa Ana River's capacity. By the 1920s, extensive water-well drilling caused dropping water-well levels, and Anaheim's water supply became a cause of concern. The Colorado River, over 250 miles distant, would be the town's salvation. Anaheim became one of the original "Thirteen Golden Cities" that created the Metropolitan Water District of Southern California (MWD). In 1931, voters approved $220 million in construction bonds, a staggering amount during the Depression. The massive construction project, carried out in harsh desert conditions, became a favorite destination for inspection trips sponsored by the member cities. In this mid-1930s view, Anaheim City officials and businessmen view the early construction along the Colorado River.

Six

CELEBRATIONS

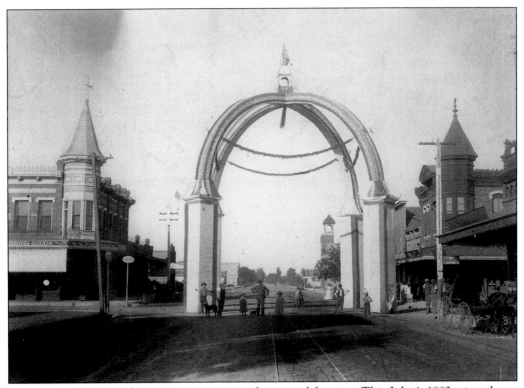

Anaheim residents took every opportunity to have a celebration. This July 4, 1892, view shows Center Street (now Lincoln Avenue) looking east and the double triumphal arch at Center and Los Angeles Streets (now Anaheim Boulevard) decorated in Fourth of July bunting and topped with an American flag. The 1892 city hall tower is visible in the background at right.

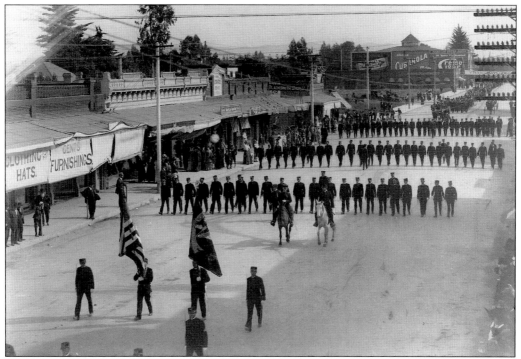

Pictured c. 1892, the Knights of Pythias, Anaheim Lodge No. 105 parade down Center Street (now Lincoln Avenue) carrying the U.S. flag. Founded 1864, the Knights of Pythias is an international, non-sectarian, social brotherhood that promotes the principals of friendship, charity, and benevolence. Pythian Lodge No. 1 was organized in 1869 in San Francisco.

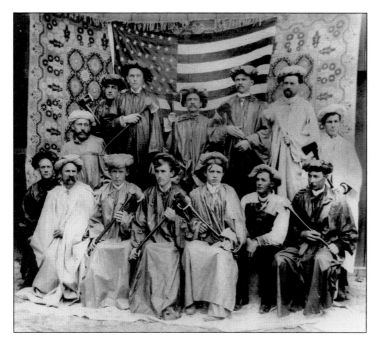

Among Anaheim's many fraternal societies was the Degree of the Woodman of the World, members of which pose here in 1898 for a formal portrait. They are wearing their formal regalia and holding axes, which are symbols of the society.

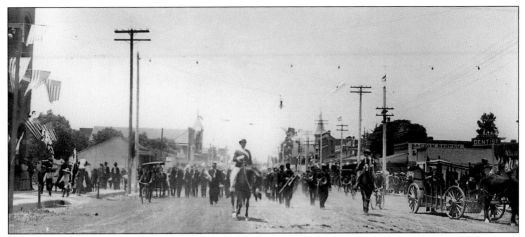

Another July 4th in patriotic Anaheim brought out the flags and bunting in 1903. Horses were still the main forms of transportation, but a few motor vehicles are now visible on the town's unpaved streets. The Anaheim City Band led the parade, and a number of horse drawn carriages carried the civic leaders. By this time, the town boasted of its modern electric light system and several miles of cement sidewalks.

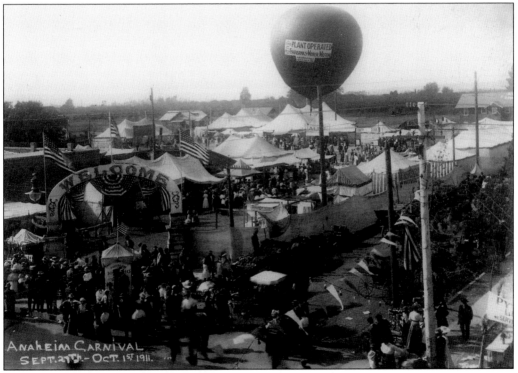

The hardworking community often took time out to throw a party. As one of the larger towns in Orange County, Anaheim became known for its many forms of entertainment. This 1911 view depicts the Anaheim Carnival, which ran for three days and was located at the corner of East Center (now Lincoln Avenue) and Lemon Streets. All types of attractions, including a balloon ride, food booths, and a sideshow featuring "Dirty Dora," were offered to those who could manage the 10¢ admission.

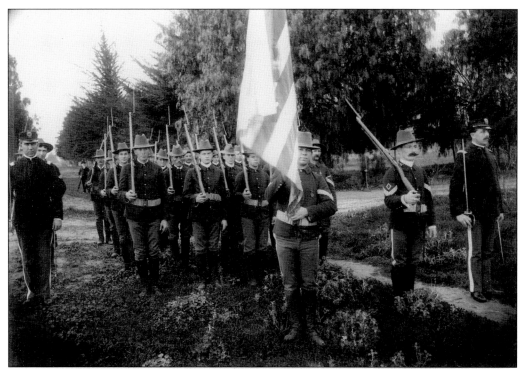

This turn-of-the-20th-century photograph shows Anaheim's Company E of the state militia, posed at attention for their annual formal portrait. The community appreciated their soldiers, made up of local farmers and businessmen who could be called upon to protect their town if necessary.

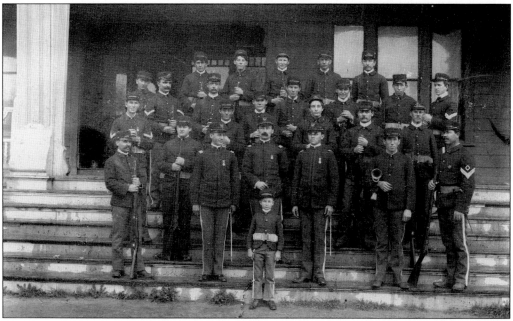

This formal 1904 photograph shows Anaheim's Company E standing on the steps of the soon-to-be razed Del Campo Hotel. Many towns maintained a small militia that was more often called upon to march in a parade than to secure the safety of the local citizens.

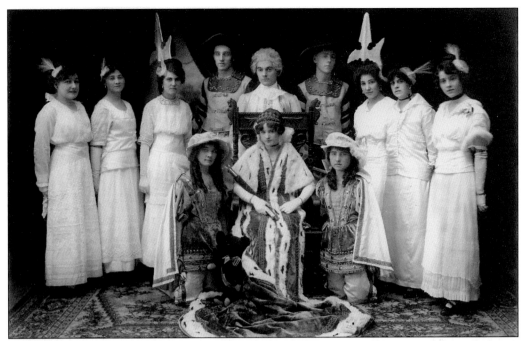

This 1916 scene shows Anaheim Carnival queen Lucille Fox and her court. Pictured, from left to right, are (first row) Ursla North, queen Lucille Fox, and Elsie Ziegler; (second row) Lucy Ziegler, Henrietta Schindler, unidentified, Morris W. Martenet Jr., unidentified, Edward Backs, unidentified, and Elsie Meinche.

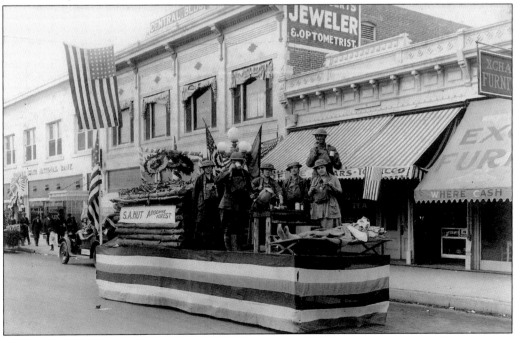

This May 30th, early 1920s Memorial Day parade featured this float depicting a Salvation Army hut in the Argonne Forest. Several Anaheim boys had seen service overseas in the "war to end all wars," and this display was especially meaningful.

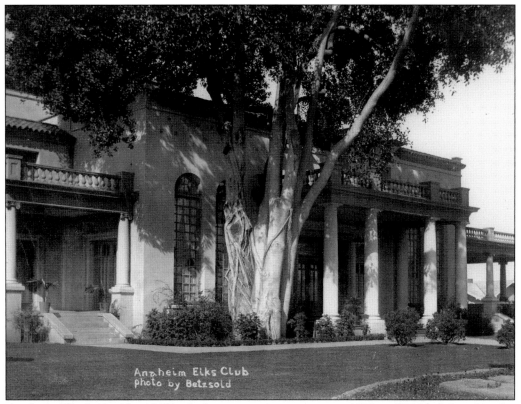

Anaheim Elks Club
photo by Betzsold

Anaheim Elks Lodge No. 1345 built this impressive structure in 1923 at 423 North Los Angeles Street (now Anaheim Boulevard). Designed by Fullerton architect Frank A. Benchley, this building provided a large meeting room that was used often by the community for receptions, parties, and civic events. Mounting debt and a June 1991 fire led to the building's demolition.

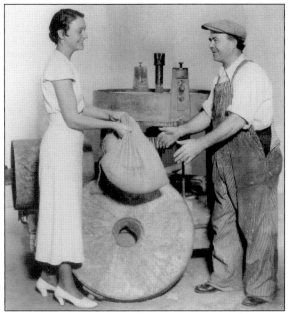

Miss Eloise Owens plays the role of a German colonist *mädchen* delivering a sack of wheat to Joseph Nagel, the miller, in this picture taken for Anaheim's diamond jubilee in September 1932. In 1875, A. Guy Smith and Company established the first grist and flourmill in Anaheim. The lost mill had been rediscovered and incorporated into the city's 75th anniversary celebration. Mayor Koesel dedicated the millstones in memory of the Anaheim pioneers at a ceremony in the city park (now Pearson Park) on September 16, 1932.

Seven

EARTHQUAKE AND FLOOD

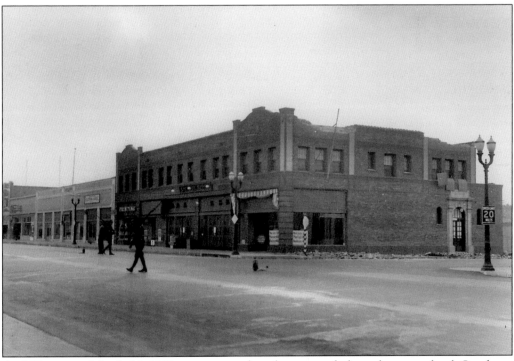

At 5:55 p.m. on March 10, 1933, a severe earthquake centered along the coast shook Southern California. In addition to Long Beach, where 74 died, the hardest hit communities included Compton with 18 dead, and Huntington Park with 16 lives lost. Anaheim's downtown business district suffered damage to a number of unreinforced brick buildings. This view of West Center Street (today's Lincoln Avenue) shows the national guardsman that patrolled the streets to protect residents from falling brick and plasterwork. Anaheim's proud 1912 Classical Revival high school building received enough damage to require its replacement under the new Field Act, which carefully regulated school construction after a number of schools were lost to this tremblor.

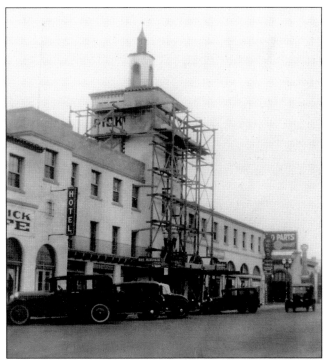

Later known as the Long Beach earthquake, the March 10, 1933, event caused damage to Anaheim's 1926 Pickwick Hotel. This view shows the hotel one-week after the quake, once repairs had begun on the hotel facade, cornices, cupola, and roof. Thankfully, no loss of life was reported in Anaheim. Local repairs, other than rebuilding the high school, were carried out fairly quickly.

This view is of the Anaheim Laundry, which was located on South Lemon Street. The building sustained significant damage, but the repairs would be rapid and the building later returned to service.

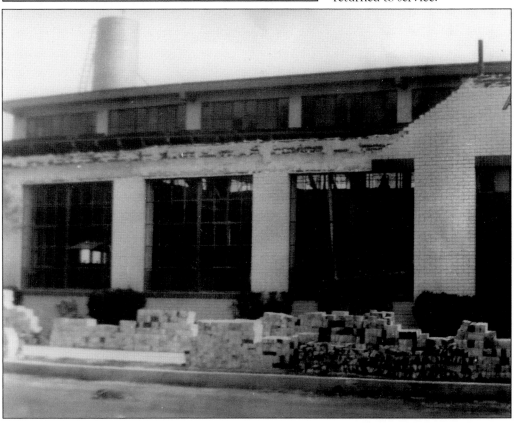

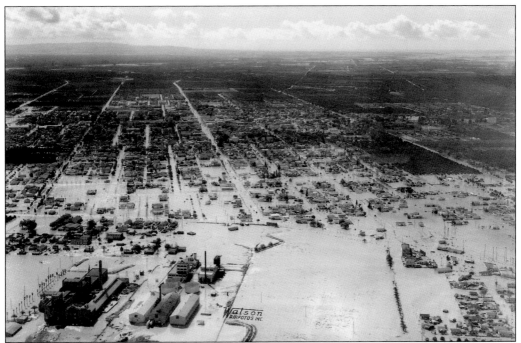

Over 8½ inches of rain fell during the 100 hours prior to 9 a.m., March 3, 1938. The Santa Ana River that drains the San Bernardino Mountains and San Jacinto watershed rose steadily until midnight March 2, when the flow exceeded 100,000 cubic feet per second, 10 times what the river banks could safely hold. At about 2:30 a.m., the major portion of the river cut through a dike north of the Yorba Bridge (today's Imperial Highway) and began its rush towards the Hispanic communities of Atwood and La Jolla, where the county suffered most of its casualties. This view of Anaheim, taken the morning of the flood, looks to the southwest. Los Angeles Street (now Anaheim Boulevard) is visible just left of center. La Palma Street (running left to right in the photograph) was the lowest point of the downtown area, and the neighborhoods adjoining it received the greatest damage.

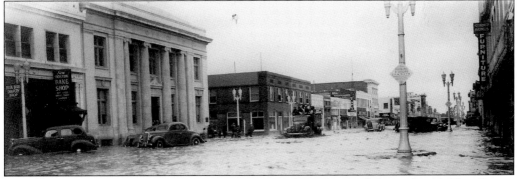

Looking west, this photograph of floodwaters near Anaheim City Hall, located at 204 East Center Street (now Lincoln Avenue), shows how much of downtown was engulfed. The waters rose over the sidewalks and flooded adjoining businesses. Center Street became a river, with wooden orange crates, lost pets, and other debris floating on the current. Most all of the stores had basements that were inundated by the waters. Although debated for decades, the need for a flood control dam in the Santa Ana Canyon was realized after the loss of 45 lives in the county. The construction of Prado Dam in 1941 has prevented such a catastrophe from reoccurring.

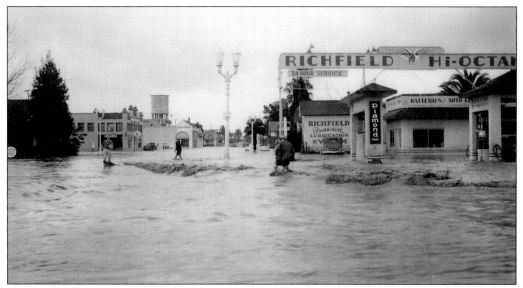

This view of South Los Angeles Street (today's Anaheim Boulevard) from the Broadway Street intersection shows the water level at mid-morning of the flood. The municipal water tower in the background is adjacent to the city's powerhouse, where operator Oren Morey sounded the first warning whistle at 4:15 a.m., awaking Anaheim's sleepy residents to the impending disaster. As floodwaters filled the basement of the telephone company building on North Lemon Street, all communication with the outside world was lost.

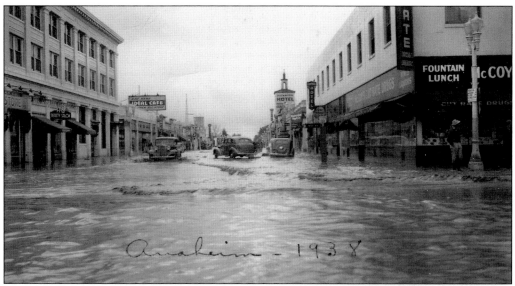

This south-facing view of Los Angeles Street (today's Anaheim Boulevard) shows the receding floodwaters on the morning of the flood. Once the water drained away, the muddy oil-slicked streets dried out and small dust storms blew throughout town, further adding to the resident's plight. The WPA crews, who were already in town for water and electric line improvements, were transferred to cleanup duties. They operated two dumptrucks working 21 days and hauled 378 loads of mud from Anaheim's downtown streets.

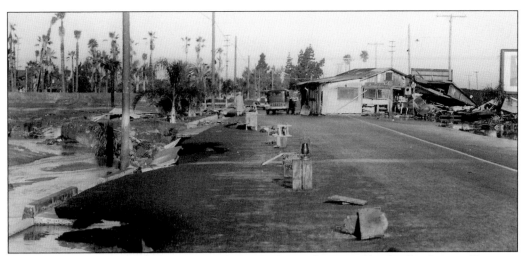

Anaheim's newest civic improvement, La Palma Park, was devastated by the floodwaters. Fourteen tall palm trees were washed away, eight of which were never recovered. A house that floated off its foundation is visible in the middle of North Los Angeles Street, on the north side of the park. The park sat adjacent to the old natural watercourse of Carbon Canyon Creek. By nightfall of March 2nd, most of the area around the new park was already underwater.

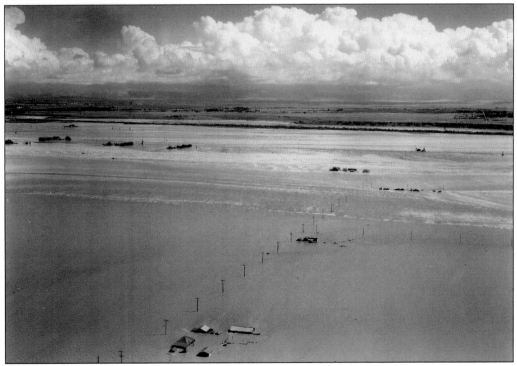

The flood of March 3, 1938, affected almost all of Orange County. Even though the area was only lightly settled at the time, the loss of its 20 residents, most of whom lived in the Hispanic communities of La Jolla and Atwood, was nonetheless very tragic. Most of the county was beneath a sheet of water that extended from Fullerton down to Huntington Beach, where the floodwaters finally met the Pacific Ocean. The Red Cross came to the county's aid, setting up a number of tent cities to deal with the high level of homelessness caused by the flood.

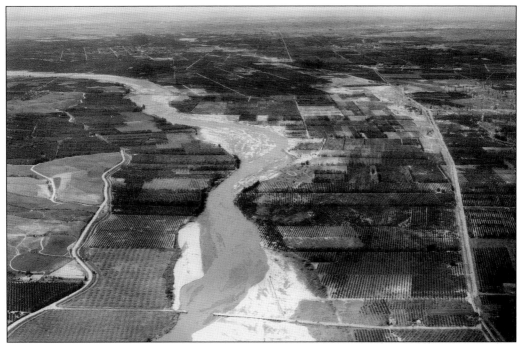

This photograph of the Santa Ana River, taken one week after the flood, shows the river receding to its banks. Anaheim is visible above the curve of the river at upper left, with Santa Ana Canyon Road on the lower left. Immediately after the catastrophe, Anaheim's chief of police, James S. Bouldin, had a force of 105 men, including the National Guard, patrolling the north end of Anaheim to protect it from looting. All out-of-town traffic was stopped and questioned before driving into the area of damage.

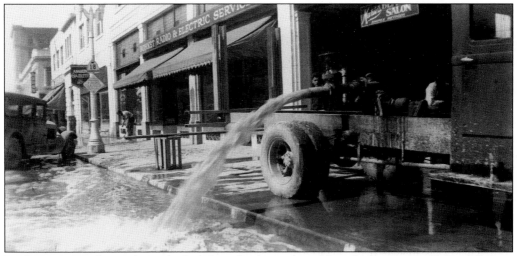

Looking west on Center Street (today's Lincoln Avenue), visible is the basement of Marie's Beauty Salon being pumped out after the March 3, 1938, flood. This scene was repeated for almost all downtown businesses and took several days to complete. Thereafter, the business owners needed to deal with the water- and oil-soaked merchandise that remained. By midsummer, most of the local devastation was a memory, as the community quickly rebuilt with assistance from the federal government through the WPA.

Eight

RECREATION AND ENTERTAINMENT

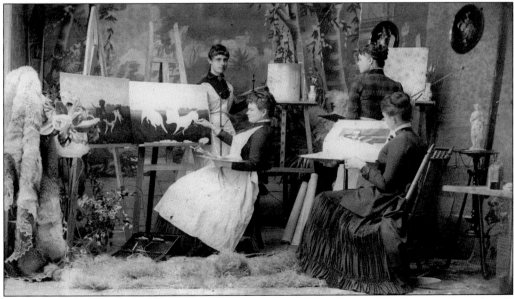

This *c.* 1885 photograph shows Thomas and Clementine Schmidt's daughters, Frances Schmidt Bullard, Clementine Schmidt Turck, and Rose Schmidt Dickel engaged in painting lessons in the parlor of the August Langenberger's Villa Mon Plaisir ("Home of my Pleasure"), located on Sycamore at Lemon Street. Each young lady is equipped with her own easel and other painting materials.

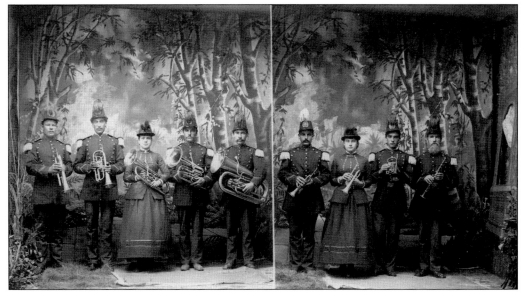

This 1870 picture shows Anaheim's first city band, which consisted of nine members (seven men and two women) all dressed in matching uniforms. From left to right are the following: Henry Padderatz Jr. (first boy born in Anaheim), Ramon Aguilar, Mrs. Ed White, Albert Bittner, Ed White, Nick A. Bittner, Clara Rust Bittner, Willis W. Weaver, and Elisha A. Pullen. Community bands were popular for many occasions and celebrations, from hotel openings to Fourth of July parades.

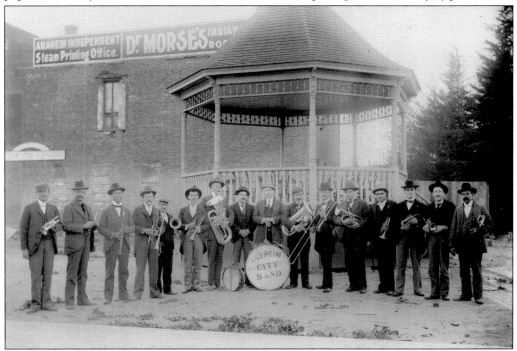

Several bands existed in Anaheim, including the Anaheim City Band, an 18-piece (16 shown in this photograph) brass band, led by Jesse W. Whann, an accomplished cornetist who had an exceptionally large and popular following in the late 1800s. During the summer, they gave weekly concerts at the bandstand on the vacant lot, where the Planter's Hotel once stood.

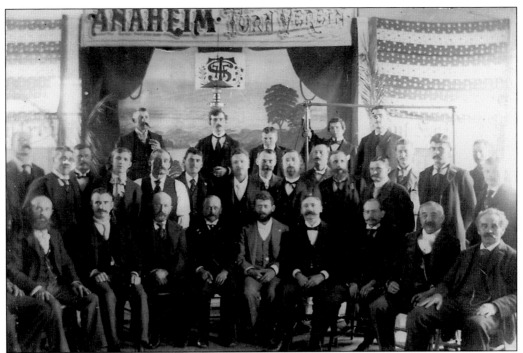

The Anaheim Turnverein Society numbered approximately 30 members. They were a group of men and women that cultivated the arts of singing and gymnastics. In this *c.* 1890 photograph, they proudly pose under their banner announcing their social and cultural contribution to the town. The society held local exhibitions of their athletic prowess, as well as picnics and outings throughout early Orange County.

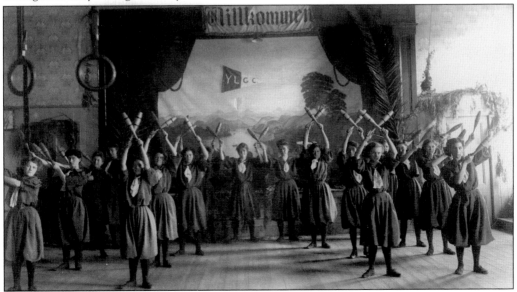

These 16 young Turnverein ladies are posed in a gymnasium with their Indian clubs. Their sign reads "Wilkommen," German for "Welcome." Tivoli Gardens, a gathering place for Turnverein groups, was later renamed Columbia Gardens, which was located on West Broadway. The Gardens were sold in 1921 to the Anaheim Concordia Club.

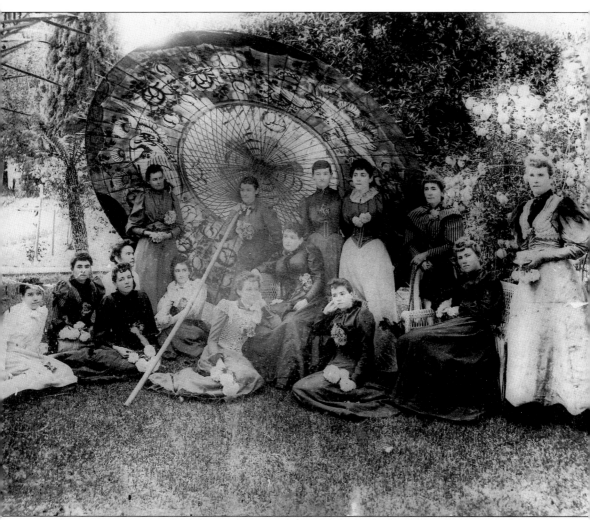

In this 1891 view of the Felicidad Parlor of the Native Daughters of the Golden West, we find 15 debutantes, many of whom are the daughters of Anaheim pioneers, relaxing in the Langenberger gardens. The large painted umbrella was a gift from the Native Sons of the Golden West's San Francisco Parlor, presented by its president, Dr. G. B. Zeyn, son of John Peter Zeyn, an original Anaheim pioneer. The Native Daughters and Native Sons are fraternal and patriotic organizations dedicated to preserving California history.

This 1893 view of Frank Ey's Barbershop on West Center Street (now Lincoln Avenue) shows a group of 12 men and boys who have just returned from a rabbit-hunting party. Such entertainment was fairly common in the community's early days, as the proximity to the "country" was not far and the resulting catch could make for a fine dinner!

In the late 1890s, Frank Eastman, Anaheim's RFD postal carrier for Route 1, drove a cart drawn by pair of harnessed ostriches named Napoleon and Josephine. This photograph was labeled, "The first trained Ostrich in the United States W. Frank and F. Eastman Trainers and Owners Anaheim." Standing next to the cart is Willard A. Frantz, an Anaheim barber. The men also raced the ostriches at the Coronado Beach Race Track, near San Diego.

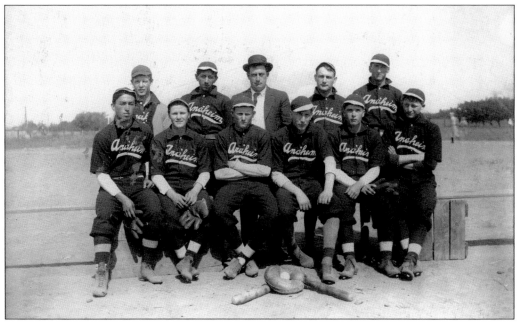

Anaheim had long been a baseball town. Before he became famous as Walter "Big Train" Johnson, the future pitcher for the Washington Senators played dirt-field ball with this Anaheim team. A teenaged Johnson is third from the left in the front row.

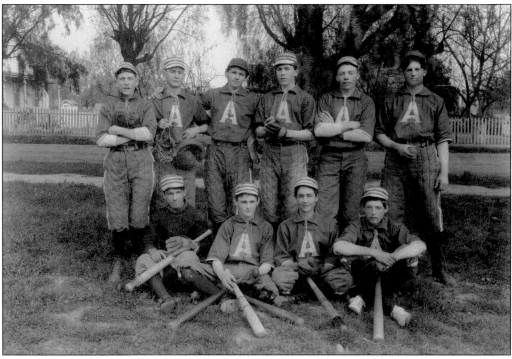

This early-20th-century view shows another Anaheim baseball team. The young players, from left to right, are (first row) Ned Merritt, Chris Fisher, Fay Lewis, and Dwight Stone; (second row) (back row) E. Hartung, Bill Fisher, Ted Dickel, Elmer Stone, H. Westerman, and Fred Conrad.

The Anaheim High School track team was victorious at the 1913 Orange County Triangle League meet. Pictured, from left to right, are (first row) Edward Hemmerling, Clevenger Megede, Harry Clabaugh, and unidentified; (second row) Morris W. Martenet Jr., Robert Gregg, Walter Paulus, George Kemp, Foster Chambers, and Darrell Webb.

Members of the Anaheim High School basketball team in 1914 included, from left to right, Coe Wellman, Jack Spencer, Clarence Beebe, Morris W. Martenet Jr., Edwin Miller, Clark Chamberlain, and Coach Benjamin Milliken. These athletes are standing on the grounds of the two-year-old high school at West Center (now Lincoln Avenue) and Citron Streets.

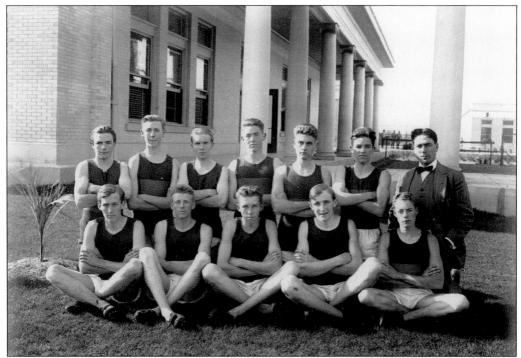

Members of the Anaheim High School track team posed for this 1914 portrait. Coach Milliken's track stars are, from left to right, (first row) Coe Wellman, Harold Douglass, Clarence Beebe, Morris W. Martenet Jr., and George Kemp; (second row) Jack Doty, Edward Backs, Foster Chambers, Clark Chamberlain, Edwin Miller, and Clevenger Megede.

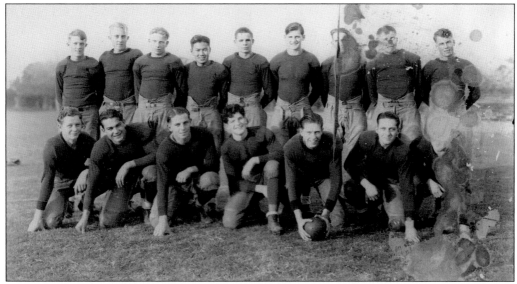

Members of the 1927 Anaheim High School football team posed for this view on the school's athletic field. Pictured, from left to right, are (first row) Erich Borchent, Harold Hylton, Walter Jungkeit, John Eley, Albert Kluthe, Floyd Lakeman, and Donald Baum; (second row) Don Reed, Herman Lenz, Franklin Van Meter, Kenneth Tanaka, Jack Dutton (Anaheim mayor 1970–1973), Richard Lusk, Vernon Rockwell, John Heide, and Gus Lenain.

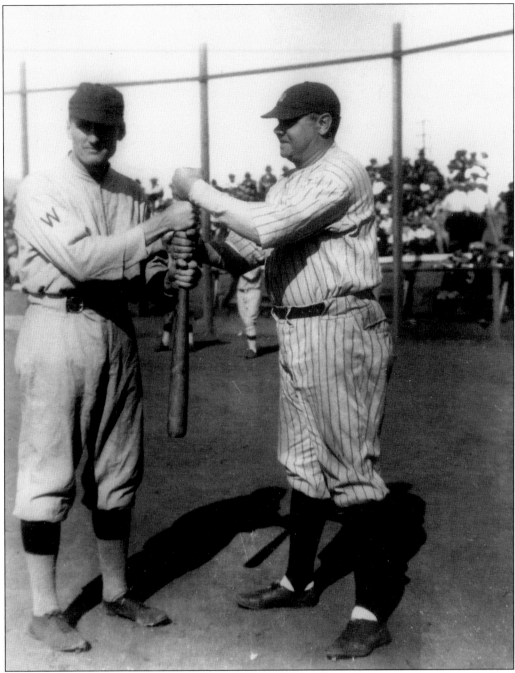

Walter Johnson (pitcher for the Washington Senators) and Babe Ruth of the New York Yankees are pictured here hamming for the camera during their October 31, 1924, exhibition game at the Brea Bowl. The teams were playing for the benefit of the Anaheim Elks Christmas Charity Fund. Later in the evening, both sports celebrities acted as grand marshals at Anaheim's inaugural Halloween Parade.

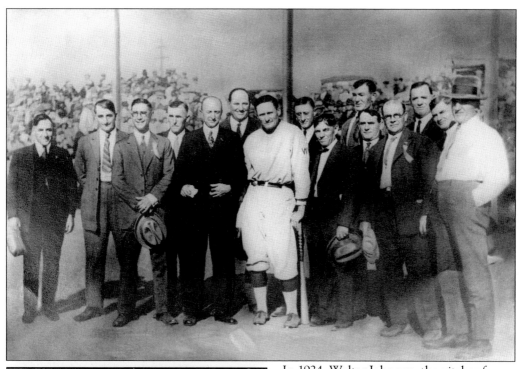

In 1924, Walter Johnson, the pitcher for the Washington Senators from 1907 to 1927, joined Babe Ruth and the Ruth All Stars on a barnstorming tour of the country. On Halloween, they visited Brea and played the local Anaheim Elks team. Johnson, also known as "Big Train," is pictured in the center of this photograph, while Joe Burke, manager of the losing Anaheim Oil Wells team, is at far right.

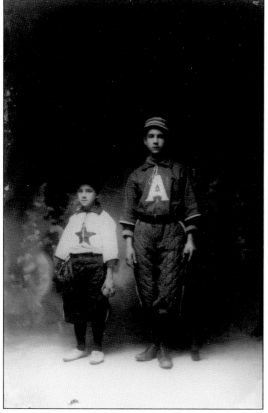

This formal photograph shows 14-year-old Lafayette Lewis and his younger brother Leland, both dressed for a baseball game. These were the children of Arthur L. Lewis, Anaheim city councilman and superintendent of the Anaheim Municipal Light and Water Works.

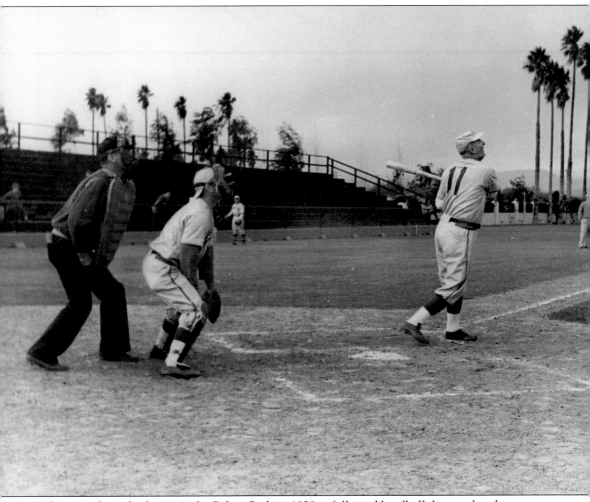

When Anaheim built its new La Palma Park in 1938, a full-sized hardball diamond and concrete bleachers were included. The Anaheim community had long supported a number of their small Pacific Coast League teams, and several businesses and fraternal organizations also fielded baseball teams during the summer. The combination of Southern California's mild climate and strong marketing by the chamber of commerce brought the Philadelphia Athletics to town for spring training from 1940 to 1942. This 1940 scene from an exhibition game at the park shows Anaheim Police Chief James S. Bouldin trying his luck at bat.

On June 11, 1927, a total of 68 members of Anaheim's pioneer families attended the second-annual Pioneer Picnic at the city park (now Pearson Park). In addition to many of the old Anaheim families in attendance were community leaders of the past and a number of Anaheim's future leaders as well. The *Anaheim Gazette* gave this meeting extensive coverage and interviewed a number of the members about their recollections of the old days.

Nine

LIBRARIES, SCHOOLS, AND CHURCHES

Anaheim's Carnegie Library building is pictured here in 1915. As early as 1871, the pioneers realized the need for a lending library. Soon 102 subscribers (paying an annual fee of $5) were using the library services of Messrs. H. S. Austin and P. A. Clark, at their stationery store. By early 1906, the chamber of commerce, realizing the positive image a new library building would have on prospective residents, contacted Andrew Carnegie's secretary to request a $10,000 pledge from the philanthropist, who was funding libraries around the world. After "Original City Lot No. 45" was purchased at the discounted price of $2,400 by public subscription, construction commenced. A grand opening was held on New Year's Day, 1909.

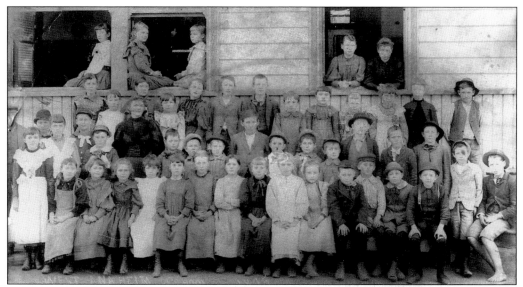

In 1869, a small farming community named Fairview was established southwest of Anaheim by Benjamin Kellogg. After Kellogg donated the land for its construction, a school was built in 1870. By 1888, a larger school was needed, and a new $7,000 building was opened in January 1889 at what was called West Anaheim. By 1899, it was finally known as Loara School, which continues today as one of Orange County's oldest school sites. This 1895 class portrait shows students of all eight grades who shared the school's two classrooms.

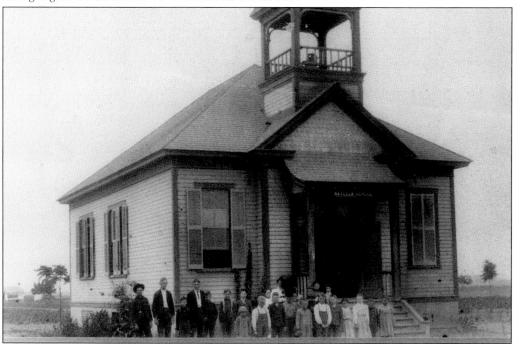

In 1896, Katella School, a one-room, wood-frame grade school, was located at the southwest corner of Katella and West Streets. John B. Rea, a community leader and rancher, blended the names of his oldest and youngest daughters, Kate and Ella, to form the name Katella as a name for his ranch, which was located at Katella and Nutwood.

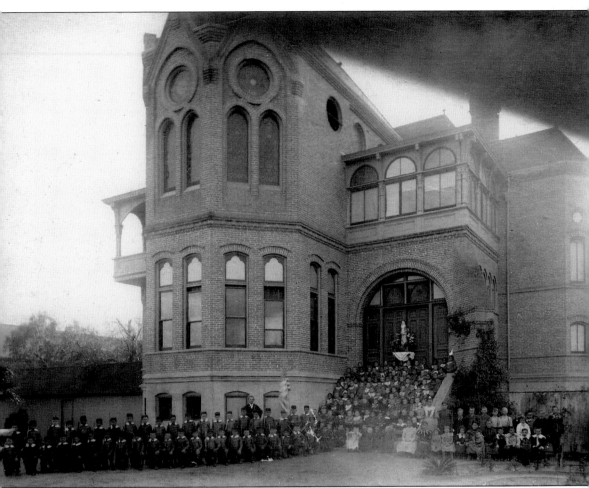

In 1887, Rev. Peter Stoetters from Anaheim's St. Boniface Catholic Church invited the Dominican Sisters of San Jose to create a new Catholic school. By spring of 1889, the new St. Catherine's School, located at 215 North Palm Street (now Harbor Boulevard) was opened with an enrollment of 20 students. Unable to survive financially, the school was later converted into an orphanage, as pictured here on March 21, 1899. With a decrease in local orphans, the school later became a military school for boys. Heavily damaged in the 1933 Long Beach earthquake, the original brick buildings were replaced. St. Catherine's Military Academy continues today, educating both day and resident students, and it is one of Orange County's oldest elementary schools.

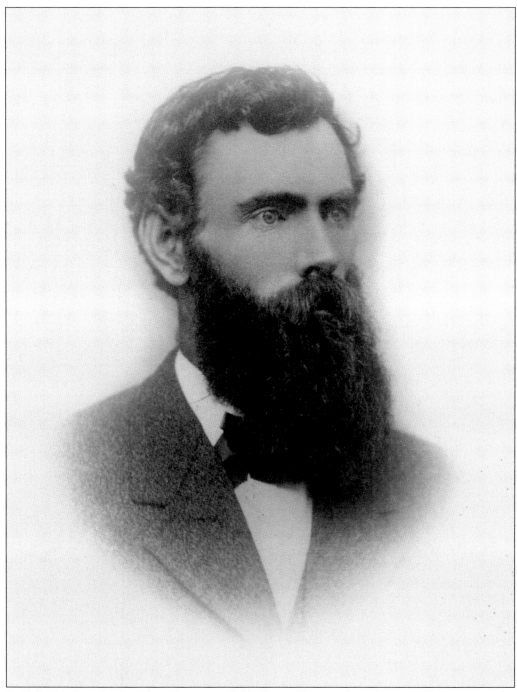

In 1869, Anaheim's school board appointed Oberlin College graduate James Miller Guinn as the head schoolmaster. Guinn was one of the first to classify the pupils into grades. He suggested an 1870 election to levy sufficient taxes to raise $2,000 for a much-needed school building. In 1877, Guinn drafted the legislative bill authorizing the passage of a $10,000 bond for the new two-story school where Anaheim's George Washington School later stood. This was the first school in California to use bonds for this purpose.

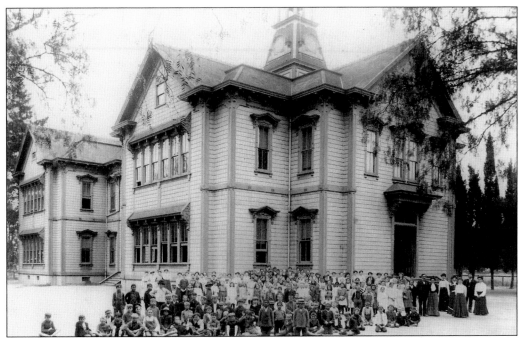

A group portrait shows children and teachers from Anaheim Central School, located at 231 East Chartres Street. The two-story wooden school was built in 1877 for $1,500. It featured a clock steeple and bell tower and housed elementary through high school classes.

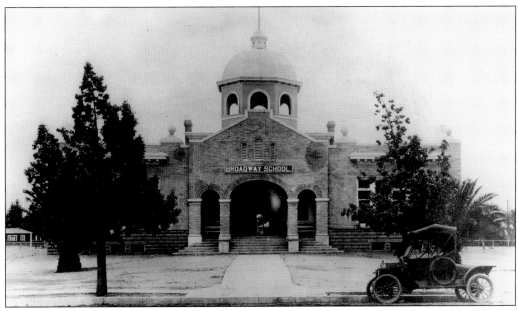

Anaheim Primary School was built in 1908 and was located at 412 East Broadway at Olive Street. The name was changed in 1910 to Broadway School, after the street on which it was located. In 1914, construction doubled the size of the school to accommodate kindergarten classes. The brick facade of the building included a striking image with an American flag flying from a flagpole on top of a large cupola.

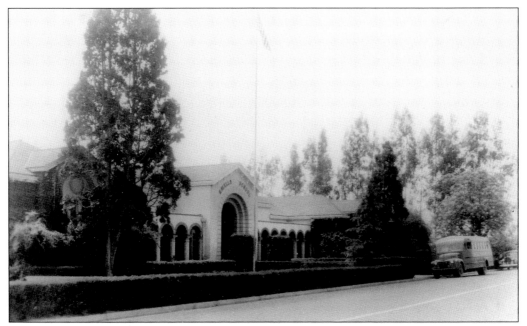

By the 1920s, the Katella one-room country schoolhouse was replaced by this proud structure. The business and building boom of the twenties encouraged many new young families to move into the area and meant that an enlarged structure was necessary. This facility continued to educate Anaheim's children until it was razed in 1969 for street widening and motel construction.

This 1926 view shows St. Joseph's Academy, located at 407 West Broadway, Anaheim's first Catholic school. Opened in 1912 by the Sisters of St. Dominic from Havana, Cuba, it later became Marywood High School for Girls, run by the Sisters of Providence of St. Mary-of-the-Woods. This impressive facility was razed as part of Anaheim's downtown redevelopment in the late 1970s.

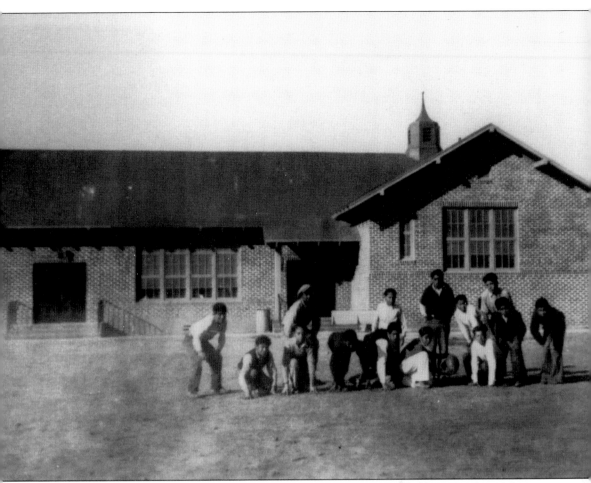

La Palma School was built in 1928 as a segregated school for Latino children. Anaheim's Latino population provided the labor force to maintain the area's many groves and handled much of the fruit-picking effort as well. Unfortunately, Anaheim's subtle segregation was carried out in its schools, churches and even at the city park plunge, where "non-whites" were only permitted to swim on Mondays, the day before the Olympic sized pool was cleaned. In 1946, the precedent setting case of Mendez vs. Westminster ended segregation in California Public Schools. Within a few additional years, many of the other vestiges of this dark era in Anaheim had ended.

Anaheim's original Central School was replaced with this structure, named George Washington Elementary School. Located at 233 East Chartres Street, the school was closed in 1998 and later replaced with a neighborhood park of the same name.

Horace Mann Elementary School was dedicated in 1932. Named in honor of the father of American public school education, the new school was located at 915 North Palm Street (now Harbor Boulevard). Educating the community's children who lived on the expanding north fringe of town, the institution expanded its campus with modern buildings in 1954, while the original building was closed in 1970.

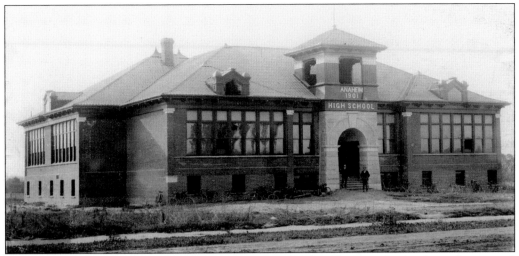

Anaheim High School, built in 1901, was the first high school built in the Anaheim district and the third in Orange County. This imposing brick structure was located at 608 West Center Street (now Lincoln Avenue). It was later sold to the elementary school district in 1911 to become Fremont Elementary School, when increased enrollment required a larger high school to be built.

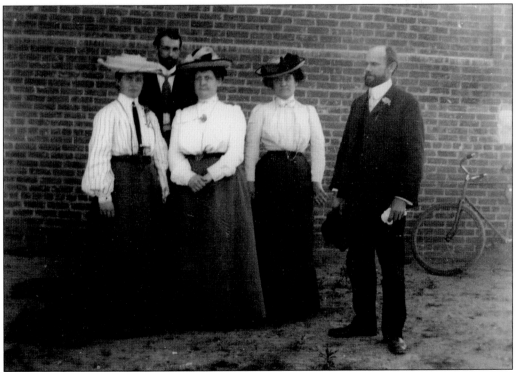

This *c.* 1901 group portrait of the Anaheim High School faculty shows four instructors and Principal Franklin, standing at far right. E. Kate Rea, at far left, taught in the Anaheim school system from 1901 until her retirement in 1921. John and Margaret Rea settled in the Anaheim area in 1896. Anaheim's Katella Avenue derived its name from the combined names of Rea's daughters, Kate and Ella.

Anaheim opened its first public high school in 1901. This view is of the modest graduating class of 1902 that consisted of Arthur G. Baker, Carl Zeus, Olga Boege, and Ruth D. Enearl.

This portrait is of the Anaheim High School class of 1911, the last to graduate from the original 1901 high school building. These 11 members lived to see dramatic changes in the town of Anaheim over the next few decades.

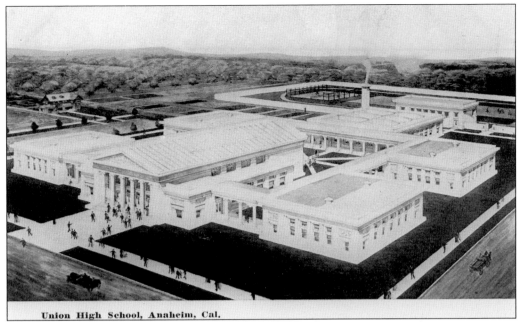

Union High School, Anaheim, Cal.

Anaheim built a new, much larger high school facility at 811 West Center Street (now Lincoln Avenue) in 1912. This birds-eye architectural rendering shows the Classical Revival–styled building and the general layout of the campus. It was a very proud addition to the community, until hidden damage caused by the Long Beach earthquake required its demolition.

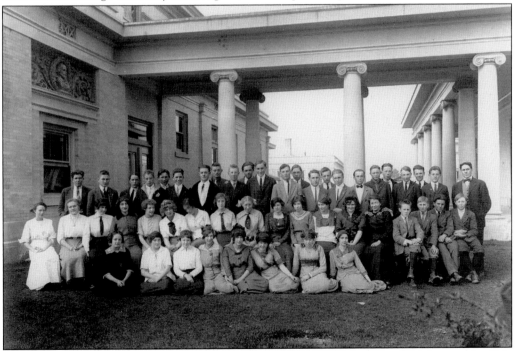

This view of the Anaheim High School class of 1916 shows athlete Morris W. Martenet Jr., 11th from left on the third row, who would make his alma mater proud when he was elected to the Anaheim City Council in 1932.

Anaheim dedicated its new John C. Fremont School in 1939. Named for the California explorer, soldier, and presidential candidate of 1856, this modern facility replaced Anaheim's original 1901 high school building that had been converted to elementary school use in 1911. This modern building of the WPA era was later converted to Fremont Junior High School but succumbed to Anaheim redevelopment in 1979.

In the 1920s, Anna Siegel was the proprietor of the Anaheim Conservatory of Music, located at 705 West Center Street (later Lincoln Avenue) at Resh. The conservatory was a modest single-story stucco building in which Anaheim's youth were trained in the fine art of music.

The 1912 high school building sustained enough damage in the March 10, 1933, earthquake to require a thorough inspection. A number of unreinforced walls, damaged trusses, and other concerns required the replacement of the apparently sound structure. Anaheim, at this time in the middle of the Depression turned to the federal government for financial assistance. Through the Public Works Administration, funding became available to construct a new building, meeting the new school earthquake standards recently enacted. With local labor and materials provided by Anaheim firms, this modern, electrically heated building, featuring an auditorium that seated 1,600, was opened for classes in 1934. It continues today to educate Anaheim's high school–aged children.

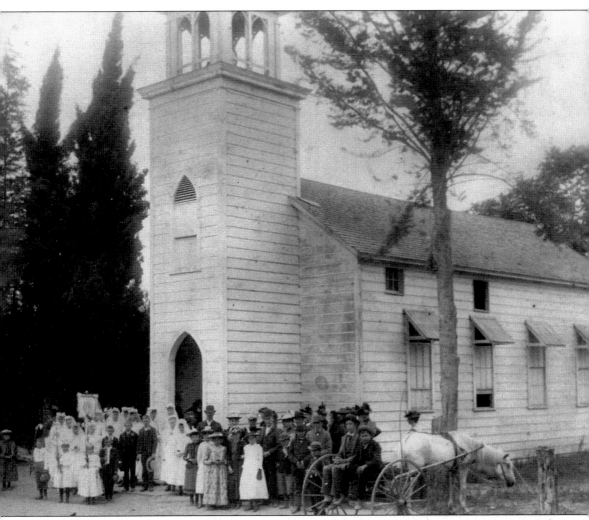

In 1870, St. Boniface Catholic Church was the first church building in Anaheim. It was constructed on a lot donated by the Anaheim Union Water Company and was located next to the city jail on Cypress Street. This larger, 1879 clapboard church replaced the more lightly built original. Measuring 42 by 20 feet, it was erected in three weeks and cost $1,000 to construct. Here we see a group of parishioners dressed in white for their first holy communion.

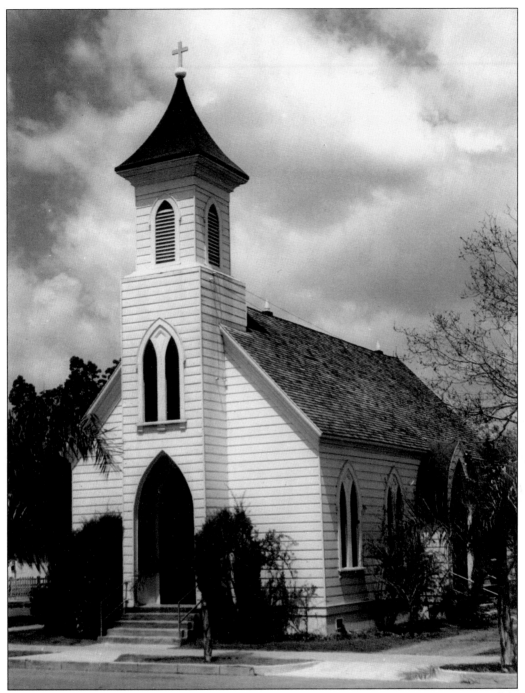

In 1876, St. Michael's Episcopal Church was built at the northeast corner of Emily and Adele Streets, on donated lots. The $3,650 edifice was built through the efforts of Susan and Elizabeth Lafaucherie, who had started an Episcopal Sunday school. Rev. Charles Loop had conducted the first Episcopal church services in Anaheim on August 24, 1873, in the Enterprise Hall, located at Los Angeles (later Anaheim Boulevard) and Chartres Street. Moved in 1955, the church continues today at 311 West South Street.

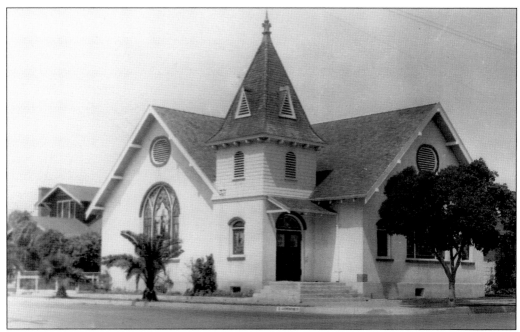

In 1881, the German Methodist Episcopal Church was established on West Broadway at South Clementine Streets. Later it became known as the Free Methodist Church. The building's facade featured two arched stained-glass windows illustrating "Christ in the Garden of Gethsemane" and "The Good Shepherd," on either side of a small steeple over the corner entranceway.

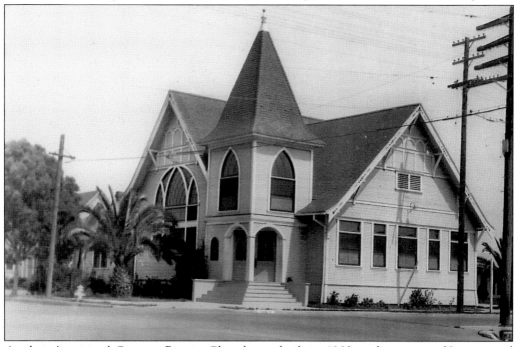

Anaheim's original German Baptist Church was built in 1903 at the corner of Lemon and Broadway. This handsome wood-framed, arch-windowed church served until replaced by the new Bethel Baptist Church, dedicated in 1927.

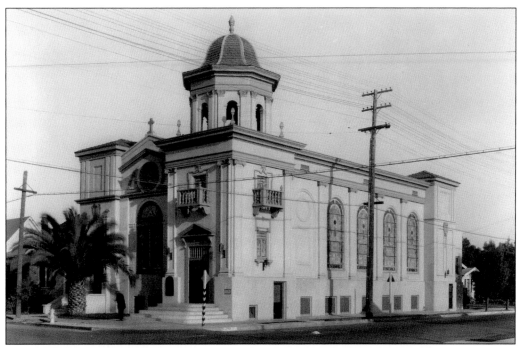

The Anaheim Bethel Baptist Church was dedicated in 1927 at Broadway at Lemon Street. It replaced the original German Baptist Church. The brick structure has a bell tower and arched stained-glass windows, with an entrance topped with a steeple.

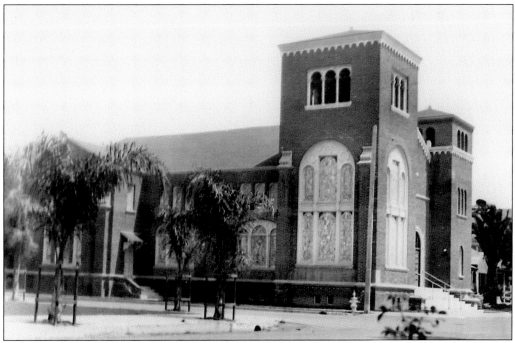

This 1925 view shows the second church built for the Anaheim Zion Lutherans, located at 120 North Emily at Chartres Street. This congregation was established in Anaheim in 1895 and built their first edifice upon incorporation in 1903.

In 1873, a petition by 24 residents prompted the building of the First Presbyterian Church. The $3,000, 30- by 50-foot, wood-frame structure was located at Los Angeles (now Anaheim Boulevard) and Sycamore Streets. Rev. Lemuel P. Webber, who later founded the community of Westminster, was the first pastor. In 1904, when two lots by Richard Heimann and Oscar George were donated, architect Charles Giddes of San Francisco drew up the plans for an enlarged building that was relocated to 125 East Cypress and Claudina Streets. In 1929, the church was sold to the Church of the Nazarene. In the early 1930s, the building was last sold to the Salvation Army.

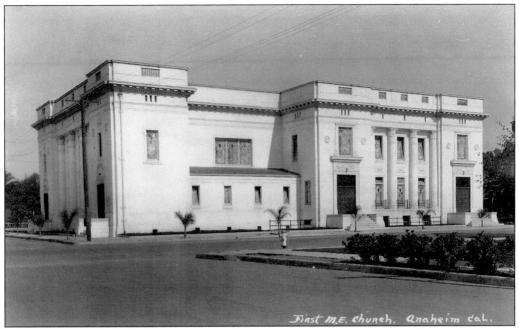

First M.E. Church. Anaheim Cal.

Anaheim's First Methodist Episcopal Church began construction in 1916. This 1917 view shows the completed church that was located on South Philadelphia Street at Broadway. Long known as the White Temple Methodist Episcopal Church, it survived until razed in the late 1970s to make way for downtown redevelopment.

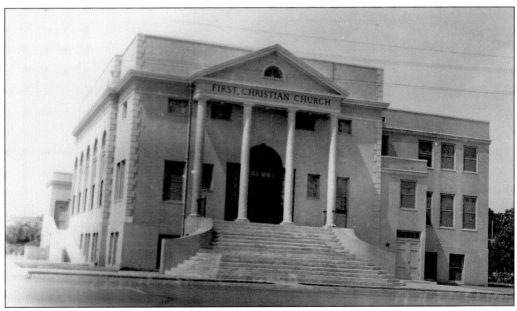

FIRST. CHRISTIAN CHURCH

This view is of the second church edifice built by the First Christian Church in Anaheim. Located at 335 West Broadway, this replaced their original facility at Center Street and Helena that was built when they incorporated their church in 1894. This two-story building was dedicated in 1924.

In the early 1920s, The Japanese Free Methodist Church was established at 1024 North Palm Street (now Harbor Boulevard). This one-story wooden structure was rented to the congregation for $5 a month. The building was moved to 914 North Citron Street after the flood of 1938.

This 1933 view shows Anaheim's Four Square Church, located at 1317 West Broadway. Originally known as the Four Square Gospel Lighthouse Church, it was affiliated with Aimee Semple McPherson's Los Angeles ministry. This local landmark structure finally succumbed to Interstate Highway 5 expansion in 1999.

The Rimpau Mausoleum is located in the Anaheim Cemetery on East Sycamore Street. This is the oldest public cemetery in Orange County and contains the final resting-place of many Anaheim pioneers. The small, family mausoleum is constructed from stone and marble, structurally demonstrating both gothic and neoclassical influences. The name "Rimpau" is engraved upon the lintel. The floral wreath at left bears the word "brother," which possibly could have been for the death in 1916 of Adolph Rimpau, one of the 17 Rimpau children.

In 1866, the Los Angeles Vineyard Society established the Anaheim Cemetery as the first public cemetery in Orange County. In 1917, the Pioneer Memorial Archway was donated and erected by F. A. Hartman, nephew of Theodore Reiser, an original colonist. It marks the original entrance to the Anaheim Cemetery from Center Street (now Lincoln Avenue). At the time, the cemetery was in very poor condition. Hartman offered the arch to the community as an incentive to other civic leaders to step forward to renew "Gottes acker" (God's Acre), where many of Anaheim's Los Angeles Vineyard Society pioneers rest in peace.

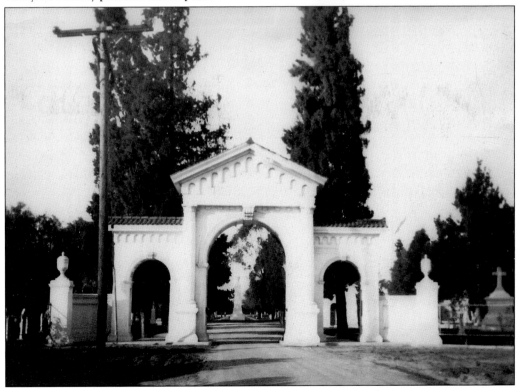

DISCOVER THOUSANDS OF LOCAL HISTORY BOOKS FEATURING MILLIONS OF VINTAGE IMAGES

Arcadia Publishing, the leading local history publisher in the United States, is committed to making history accessible and meaningful through publishing books that celebrate and preserve the heritage of America's people and places.

Find more books like this at
www.arcadiapublishing.com

Search for your hometown history, your old stomping grounds, and even your favorite sports team.

Consistent with our mission to preserve history on a local level, this book was printed in South Carolina on American-made paper and manufactured entirely in the United States. Products carrying the accredited Forest Stewardship Council (FSC) label are printed on 100 percent FSC-certified paper.

MADE IN THE USA